THE
MAKING OF AMERICA
SERIES

NORTHEAST GEORGIA

A HISTORY

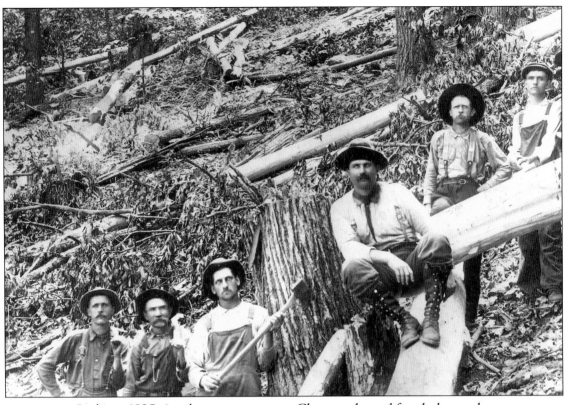

In this c. 1925 view, loggers cut trees near Clayton to be used for telephone poles.

THE
MAKING OF AMERICA
SERIES

NORTHEAST GEORGIA
A HISTORY

GORDON SAWYER

ARCADIA
PUBLISHING

Published by Arcadia Publishing
Charleston, South Carolina

Library of Congress control number: 2001095846

For all general information contact Arcadia Publishing at:
Telephone 843-853-2070
Fax 843-853-0044
E-Mail sales@arcadiapublishing.com
For customer service and orders:
Toll-Free 1-888-313-2665

Visit us on the Internet at www.arcadiapublishing.com

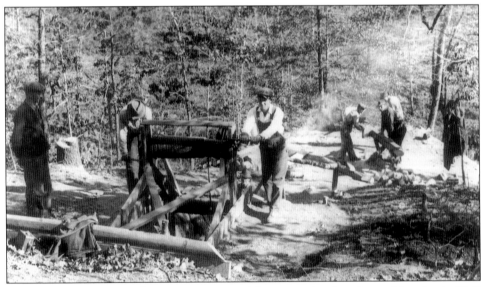

The use of shaft and windlass mining was used for prospecting for mica at this mine in Hall County in 1940.

CONTENTS

ACKNOWLEDGMENTS

The history of Northeast Georgia's mountain trade area is different from traditional Georgia history, which usually focuses on a plantation culture, the Civil War, and an agrarian economy. Even so, tucked away in almost every old book about Georgia you will find valuable bits and pieces of history describing life in Northeast Georgia: the Cherokee Indians, traders buying buckskins, the Trail of Tears, the gold rush, summer resorts, waterfalls, and hydro-electric power.

So, first and foremost, I would like to thank the historians, most of them long gone, who recognized that Georgia's mountain region was different, but made mention of it anyway. My thanks, also, to the people who saved (and identified) old photos and maps and made them available.

The Georgia Department of Archives and History is an excellent facility, staffed by knowledgeable professionals and willing helpers, and I thank them all. Many people at the archives helped with this volume, but I would especially like to acknowledge Gail Miller DeLoach, who guided me to many seldom-seen old photographs.

The Hall County Library, in Gainesville, holds a treasure of history about the mountain trade area, and I would like to thank Library Director Susan Stewart and Ronda Sanders, for their patience and help. And thanks to Sybil McRay, who, years ago, convinced the library that it should be the repository of original history, documents, and photographs about Gainesville and Northeast Georgia. A number of other organizations have been helpful in this work: the Georgia Mountain History Museum at Brenau University; the Dahlonega Courthouse Gold Museum; the Chestatee Regional Library, in Dahlonega, which houses the Madeline K. Anthony Collection on Georgia's gold rush; and the museum at the Sautee-Nacoochee Community Association. I would like to encourage the history societies that have formed, and are forming, in the mountain area. Many have been helpful in this work.

To Olin Jackson, the dedicated and capable editor of the *North Georgia Journal*, thank you for all your help, and for your guidance and encouragement. To the late Sylvan Meyer, who also worked with us in building the *North Georgia Journal*, I wish you could be here to participate in the book signings.

Richard Stone, the old-photograph magician from beautiful downtown Talmo, Georgia, deserves credit for many of the pictures in this book. Rick has always been professional in getting the most from faded photos, but his work with the new digital equipment lifts the science of restoring photos to a whole new level.

The illustrations covering the pre-photography history are the work of John Kollock, who not only is the premier artist of Georgia's mountains, but also one of the best and most accurate historians of the area. The maps are the work of Jim Chapman—artist, graphic artist, and writer-recorder of the human side of life in Northeast Georgia.

Bob Rogers, the retired but still active photographer who lives in the mountains at Skylake, provided some of the mountain pictures. His personal collection of mountain photographs is spectacular.

A special thanks to my English professor daughter-in-law, Cathryn Sawyer, for all the work and the many hours she spent on this project. And to Cathryn and my wife, Jean Sawyer, for encouraging me to keep going when things bogged down.

And finally, as a point of personal privilege, I would like to thank the late Ralph McGill, editor of the *Atlanta Constitution*, who first turned me on to the history of Northeast Georgia when I was a young, green cub reporter who drew the assignment every now and then of driving the good editor to an out-of-Atlanta speaking engagement.

One of the pleasant things about doing local history is meeting people, talking with them, and finding them to be willing workers; helping dig out information, old photos, and documents; and helping any way they can. I thank you all.

Because this book is intended as general information for those interested in Northeast Georgia, and not a scholarly document, I have avoided using extensive end notes. However, for those who might want to know where information originated, or who wish to dig deeper into any subject, it seems appropriate to list my major sources, which appear at the end of the work. Even so, it should be accepted that this is my version of the history of Northeast Georgia. If you think I am in error, the buck stops with me, not my sources.

INTRODUCTION

Certain major movements determine the character of a people or of a geographic region. These movements most often are hard to see at the time they are happening, for they occur gradually over a span of many years. Yet, they determine the culture of a people, and the type civilization you find in a given place. Some civilizations are molded by nature, by geography. Certainly that is true of seaport cities. It is also true of mountainous areas like Northeast Georgia. Others are set by tribes, or governments—by the way people organize themselves to live together. And by rebellion or war, the major moments when nations tear themselves apart, or put themselves together in a different way. Some major movements in history have been driven by religion; not only by what individuals believed, but also by the influence of powerful church bodies. And finally, the character of an area is always influenced by economics, by business. It seems fair to say the mountain trade area of Northeast Georgia has been influenced by all these major historic movements, but I have focused more on economics and business—the quest by man for a better life, the result of hard work and risky undertakings.

This book is a search for the underlying culture and the colorful character of Northeast Georgia, and especially for the economic movements that made it what it is. The book focuses on the geographic area where the Blue Ridge Mountains reach down into Georgia. For the most part it focuses on the Chattahoochee River watershed, and the mountains that surround it, although several other major rivers begin their journey in these same mountains. The book focuses on an area surrounded by large mountain lakes, with Lake Lanier on the southern end and the TVA lakes to the north.

This work is a search for the attributes that have made Georgia's mountain people stubbornly independent, fiercely self-reliant, even a bit rebellious—a people more than willing to accept newcomers, but dogged defenders of their own customs. This is a region where people always seem to be coming and going,

The mountains and foothills of Northeast Georgia provided opportunity for small farmers as the last wave of pioneers settled Georgia.

an area unafraid to accept new people and new ideas, and yet a region which has maintained a remarkably stable and conservative culture for more than 200 years.

This has been a search for the chunks of history that have made us what we are, for there is a certain unity about the people who love living in Northeast Georgia, whether they be the oldest of the old-timers or the newest of the "mover-inners."

I do not claim to be a historian; I am a reporter. I hope you will enjoy my reporting as much as I have enjoyed putting this book together.

—Gordon Sawyer
2001

9

1. The Arrival of Man

The geographic character of Northeast Georgia was molded when the land first formed. The mountains of the eastern United States came into being 300 million years ago—give or take a few million years—when the plates of the forming earth shifted and ground over each other. The hardening earth pushed up through the oceans, lifting higher and higher, and the water fell back. The Appalachian range of mountains was thus formed. At 30,000 feet, they were higher than the Rockies, or the Alps—even the Himalayas.

Today's North Georgia was at the extreme southern end of this rugged mountain range, and it is likely that the Atlantic Ocean lapped against the southern-most part of the mountains, probably as far north as today's Macon or even Atlanta. Then wind and water began the timeless erosion of these massive mountains. At about 80 million years B.C., the dinosaur roamed the Appalachian area, and plant life was abundant. The mountains had eroded significantly, but North Georgia remained a jagged, inhospitable region.

A great Arctic ice cap formed on the earth around 100,000 years ago—give or take a few thousand years. A vast amount of ocean water was locked up in these glaciers, and ocean levels dropped; some estimate the drop worldwide to be as much as 300 feet. As the ocean level went lower, water receded from the Bering Straight, the ocean passageway between present-day Alaska and Siberia. The exposed Bering land eventually became a grass-covered prairie, and caribou came there to graze. When the caribou came, the Asian-Oriental hunters of the region were not far behind. These "paleo-Indians" trekked across the new land bridge, and reaching the North American continent, turned south. This is the generally accepted theory about how the first people arrived in North and South America, but new archaeological evidence is challenging the idea that this was the only route they traveled. We'll leave that debate to someone else.

In economic terms, these Asian-Oriental hunter-gatherers were looking for a more effective way to supply themselves with food and clothing. Nomadic by

The "Indians" of America came across the Bering Straight from Asia. Indians in Northeast Georgia came by two routes: from today's Southwest and Mexico, and from the Ohio River basin.

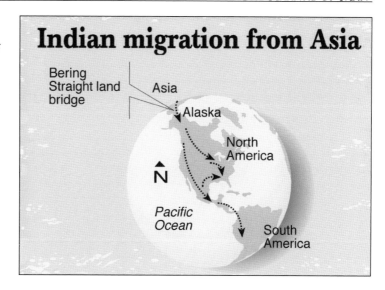

nature, they were quite willing to follow the trail to a better hunting ground. Generation by generation, they moved south for more game and a less hostile environment. There is some evidence that these first Americans of Asian descent arrived on this continent as much as 34,000 years ago. But there is only sketchy archaeological evidence of humans in the Americas prior to the so-called Clovis culture, which left distinctive stone tools throughout the Americas. These early tools are believed to be 11,000 to 12,000 years old.

For the most part, it appears that these first "Indians" turned south through Alaska and kept going all the way to Central and South America. Sophisticated societies were developed: the Incas in Peru, the Mayas in Central America, and the Aztecs in Mexico. Some historians have estimated that by the time the Europeans discovered America the two continents had as many as 80 million widely dispersed people. In this exclusive Indian culture, however, the eastern portion of today's United States was a sparsely populated outpost. Some estimates report only 500,000 of the total 80 million Indians were in North America north of Mexico, and of those, only 200,000 were between the Mississippi River and the Atlantic Ocean.

The last pre-historic Indian cultural development in North America was the Mississippian Culture, and it held forth from about 800 A.D. until the arrival of the European explorers in the early 1500s. The Mississippian Culture was generally bounded by Minnesota and Wisconsin in the north, Georgia in the southeast, and the Great Plains on the west. The Mississippian tribes were accomplished craftsmen and had an intricate system of trading that reached throughout their territory.

Always seeking better hunting grounds, Indians migrated into the southeastern portion of present-day America from the plains of the Southwest. They came about 8,000 B.C. as hunters, and by 3,000 B.C. had developed an agricultural

economy along with their hunting and gathering. They settled along the slow-flowing rivers of Florida, South Alabama, and Georgia, and developed villages with structured governments. Villages were connected by well-marked trails, and these Indians were active traders.

Southern Georgia was settled by various Indian tribes, but these first Georgians had one important thing in common: a language generally referred to as "Muskogean." Thus, the various tribes could communicate with one another, an important attribute, first in trading and later in war. These Indians are generally known in history as the "Creeks," a shortening of "Ocheese Creek," or Ocmulgee River, by the English. The Creek tribes formed a powerful confederacy, and they ruled the southeastern corner of today's United States.

While the Creek Indians farmed and lived in the fertile flatlands, they did much of their hunting in the well-stocked mountains of the Appalachians, and especially in North Georgia. Max E. White, in his book *Georgia's Indian Heritage*, says, "Members of the Creek Confederacy set out in search of game in autumn, traveling as family units," and they didn't return to their towns until March, "laden with skins and smoked meat."[1]

Deer was their primary target, for deer provided hides, meat, and horns, all useful to the tribe and for trading. But the hunters also brought back bear oil and smaller game. The North Georgia mountains were a paradise for hunters and gatherers. Wildlife was abundant: deer, elk, bear, turkey, and all kinds of small

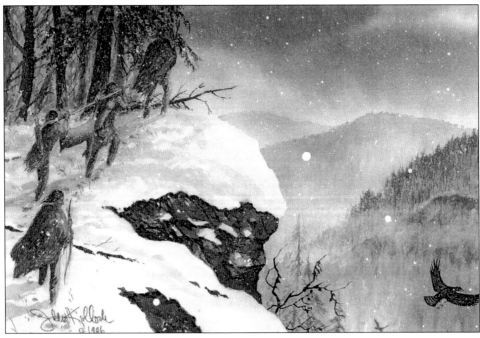

In deep snow, Indian hunters carry a deer alongside the bluffs of Tallulah Gorge. (Painting by John Kollock.)

The forest-covered mountains of Northeast Georgia range from 1,000 to 4,000 feet above sea level.

game. There is valid reason to believe some buffalo were in the area in early times. Fish filled the fast-flowing rivers. If the hunter failed to make a kill one day, no problem, for an estimated 40 percent of the trees in North Georgia were chestnuts, and the ground was covered with nuts. Food was abundant.

Traveling was not difficult, even though the mountains were steep. The animals had long since made trails, picking the easiest routes, usually along the ridge tops. The animal pathways led unerringly to the easiest places to cross rivers and streams, and they dodged the roughest mountains and the swampy lowlands.

It was this wealth of game and the ease of hunting that eventually made North Georgia one of the bloodiest Indian battlegrounds in the South. The Cherokee came into the Northeast Georgia area from the north, probably the upper Ohio drainage area. Both linguistically and culturally they were related to the Iroquois tribes, which could be found in the northeastern quadrant of today's United States. Like the Creeks, who came from the Southwest, these Cherokees from northern lands were large and powerful people—standing 6 feet or better at a time when the average European was closer to 5 feet, 4 inches. Both the Cherokee and the Creeks later would be described by European explorers as "Red Giants."

As the Cherokee migrated south, they found the Appalachians with all its wild game and food. Unlike the Creeks, who lived in the rich flatlands and came to the mountains to hunt, the Cherokee began to move into the mountainous areas

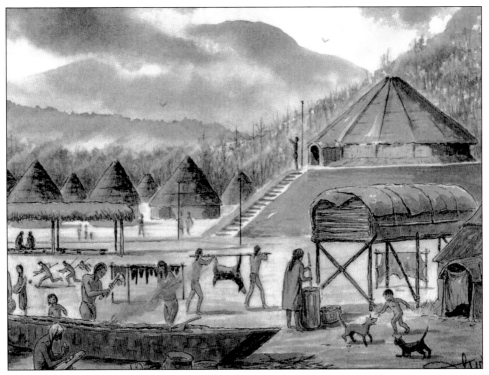

This illustration shows life in the Indian village at Nacoochee Valley before the arrival of the white man. (Painting by John Kollock.)

to live permanently. They, too, had evolved to be farmers as well as hunters, but they found the rich mountain–area river bottoms to be adequate farming lands, and much nearer the mountains with their endless supply of deer.

From an economic standpoint, as the "economy" was measured at the time, Northeast Georgia was a valuable asset. In the Indian culture of the time, that meant it was worth fighting for—either the Creeks or the Cherokee had to give it up. Indian legend abounds with tales of desperate battles between the Cherokee and the Creeks fighting in the mountains of North Georgia, and many places today carry names from those legendary battles.

No battle was more disastrous than the one fought at Slaughter Gap, between Slaughter and Blood Mountains. Although this battle was fought generations before the white man discovered there was an America, the names to be found on today's maps are "Blood Mountain" and "Slaughter Mountain," powerful reminders of the bitter rivalry that developed as the Cherokee and the Creeks fought for dominance in the great hunting lands of North Georgia.

In time, the Cherokee warriors forced the Creeks out of North Georgia, took over the land, and began permanent settlements of their own. There were many Cherokee settlements prior to the arrival of the white man. The best known in Northeast Georgia was Nacoochee, or Chota, in today's White County. This

village, combined with the settlements in nearby Sautee Valley, made up the area's largest Cherokee population. Even so, North Georgia villages of the Cherokee were always small by comparison with their main centers of population farther north in the Appalachians.

For the Indians, pre-history Northeast Georgia was the frontier, a no-man's land, the buffer between two powerful Indian tribes that might break into a brutal war at any moment. Although the battle started over who would have the right to hunt in the mountains, there is ample evidence that the Creeks and the Cherokee came to a point where they fought simply because they didn't like each other. The Cherokee won and took over the land.

It was in 1492 that Christopher Columbus became the first European to discover the New World—that is if you ignore some early Scandinavian explorers. There was great excitement in Europe, for England and Spain were in a fierce competition to develop new wealth through exploration. World exploration, world settlement, and world trade were the top economic priorities for every major nation in the civilized world. The fact that America was not a shortcut to India and the Far East was immaterial; it was new land, and it was bound to offer wealth. The Spanish government had no trouble recruiting sailors and soldiers to explore this new find of theirs—this new find we now call America.

Columbus returned to the "New World" in 1493 with another expedition, and for the next several decades, European ships of all nationalities would cover every mile of the coastlines in the Caribbean basin.

Ponce de Leon, who had come to America on Columbus's second voyage, is credited with discovering Florida while seeking the fabled "Fountain of Youth" in 1513, and eight years later led an expedition that attempted to place a colony on

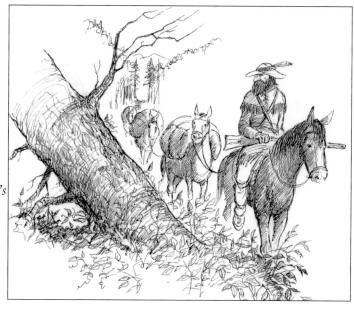

Although DeSoto was the first European to enter Georgia, the Indian trails of Georgia's mountains were first explored by fur traders with their trains of pack horses. (Illustration by John Kollock.)

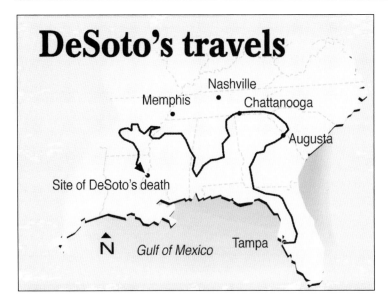

DeSoto explored the Southeast in 1539–1540, but apparently bypassed Georgia's mountain area.

the continent. He was wounded by Indians and later died of those wounds, but his expedition had heard tales of gold.

Hernando DeSoto had become wealthy and powerful in the Spanish conquest of Peru. He had been part of the force that discovered gold there, and this early discovery of gold had made Spain wealthy and DeSoto a hero. He was made governor of Cuba, and when he arrived there in 1538, he was immediately told of a "City of Gold" somewhere north of present-day Florida.

A year later, DeSoto took an expedition to the mainland, landing at Tampa with 600 fully armed Spanish soldiers, 100 assistants, 220 horses, trading trinkets, and equipment. He also had a number of large, savage Irish hounds, which were used to hunt down and capture Indians. The force would live off the land. The expedition went north, following Indian trails, and they visited their power on the Indian villages. DeSoto crossed the Georgia border on the southwest corner, probably just east of Thomasville, and they left Georgia on the South Carolina side when they crossed the Savannah River, probably near Augusta.

There is lively disagreement among scholars about the exact route DeSoto took as he crossed Georgia, and there is the likelihood that he sent scouting parties out from his main route several times. Some historians will insist his expedition touched points in Northeast Georgia, and will cite evidence. Others insist, and have strong evidence, that DeSoto missed Northeast Georgia entirely. There were four written accounts of DeSoto's expedition, and in them can be found mention of a sizeable village called "Guaxule." The historians who argue that DeSoto came into the mountains believe Guaxule was located at the mound in Nacoochee Valley on the Chattahoochee River. Those who believe DeSoto missed Northeast Georgia believe Guaxule was located on the Coosa River, not the Chattahoochee. Such is the hazard of attempting to find historical truth after more than 400 years.

Later on, the Europeans would refer to Georgia as a wilderness, populated by disorganized savages. Compared to the European civilization of the time, with the Roman-built roads and powerful governments, they were right. Even compared to the cultures of the Mayans, Incas, and Aztecs, they were correct. But what DeSoto found as he explored Georgia in his quest for gold was a land with scattered villages, an economy that provided adequate food and clothing, clear and easily traveled trails, and a reasonably-structured system of government. DeSoto did not find gold, but the Indians knew a new and powerful band of men, the Europeans, was traveling in their land. It would not be the last time newcomers would search for gold in the Blue Ridge Mountains of Georgia.

Northeast Georgia is laced with Indian names that came down, word of mouth, through the ages: Chattahoochee, Chestatee, Etowah, Coosa, Oconee, and many others. And just as these names have become a part of modern-day maps, a host of Indian legends have become imbedded in the history of Georgia's mountains.

Probably no Georgia Indian legend, however, has had more appeal, has been more enduring, than the legend of Sautee and Nacoochee; possibly because it is about young lovers. But whatever the reason, after many centuries, it lives.

The fundamental legend goes this way: The Cherokee and the Chickasaws, like many ancient Indian tribes, didn't like each other; yet, their leaders worked to keep peace. The Cherokee inhabited the beautiful valleys of Northeast Georgia, and on one occasion the Chickasaws wanted to pass through these lands, and sought to do so peacefully. Wahoo, the Cherokee chief, agreed so long as the Chickasaws stayed on the well-established Indian trail, and camped only at certain spots that were not threatening to the Cherokee.

One night the Chickasaws set up camp at the intersection of two of the most beautiful valleys in all the mountains. The Cherokee, being curious, eased over to see what these dreaded enemy warriors looked like. One of the onlookers was Nacoochee, the beautiful daughter of Chief Wahoo, and as she looked, she was drawn to a young, powerful, and attractive Chickasaw. He was, it turned out, Sautee, the son of the Chickasaw chief—and probably the one who would inherit leadership of the tribe.

There are many versions about how these attractive and promising young Indians got together, but they did, and they spent several days together in a local cave known only to Nacoochee. When Old Chief Wahoo finally got his hands on the two lovers, he announced he was going to have Sautee thrown off the bluffs of Yonah Mountain, and was going to take Nacoochee along to watch. But just before Sautee was to be thrown off the mountain, Nacoochee broke free and ran to him, and they cascaded off the mountain in each others' arms, to their death.

Tradition has it that they were buried together at the intersection of today's Nacoochee and Sautee Valleys, near the post office called Sautee-Nacoochee, Georgia, 30571. And the story says the two tribes lived together peacefully thereafter. The legend of Sautee and Nacoochee is just one of many magnificent tales about the Indians of the mountains of Northeast Georgia, and no matter how much these stories are repeated and enhanced, they live on.

2. The Frontier Reaches Georgia

As the immense wealth being created for Spain on the Spanish Main became apparent, the struggle for the New World started in earnest. To a large degree, the battles centered in the Caribbean. Although the American mainland was not the focal point, neither was it ignored. A constant stream of explorers—British, Spanish, French, Dutch, and others—touched the coast of the continent. The British planted colonies along the American coast north of Georgia. The Spanish placed outposts along the Florida coast. The French eventually worked the area in the middle of America, along the Mississippi River. So far as world power struggles were concerned, Georgia was in a precarious location.

Even so, as the explorers came to Georgia's major rivers, they probed inland. Maps became reasonably accurate as far upstream as ships could navigate. But little was known about the inland area, and few cared what was there. During the 1500s and 1600s, very little trading took place in Georgia. The Indians traded among themselves, and had very little contact with the Europeans. In the mountains of Northeast Georgia, the Cherokee ruled, but every now and then, a battle would break out between them and the Creeks. Some bold traders explored the area to trade with the Indians, and they provided information that added overland trails to the maps. While colonies were being formed along the East Coast of America by the British, and a great deal of activity was taking place in the Caribbean, Georgia for the most part lay dormant.

Then, in 1732, King George II granted a charter for a unique new colony—the only frontier colony started in the eighteenth century. The charter was for Georgia, and its port of entry would be Savannah. The King's grant encompassed a narrow strip of land between the Savannah and Altamaha Rivers, but it stretched from the Atlantic to the Pacific Oceans, and took in the present-day site of Los Angeles, California. It cut right through lands then claimed by both Spain and France.

For the most part, early English settlements were situated north of Georgia along the American East Coast. The inland Appalachian mountain areas, hard to reach and unsuited for farming, were mostly ignored for three centuries.

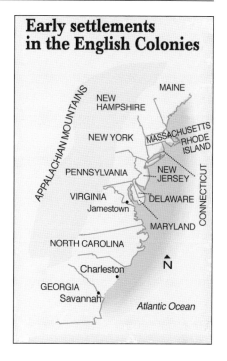

Early settlements in the English Colonies

There had been a good bit of talk in London about the need for a new colony in the New World. English businessmen were looking for new sources for some raw materials, among them rice, indigo, and silk, which they thought could be cultivated in Georgia. They also wanted to expand the market for English goods. The mercantilists saw the possibility of expanding the Indian trade in furs and skins, and possibilities for expansion of trade into new territories.

The imperialists saw the possibility of using Georgia to secure the frontier against the Spanish, French, and their Indian allies to the south and southwest. Some Indians were friendly to the English, but some were not. Georgia-based Indians had almost destroyed the English settlement in South Carolina in the War of 1715, and probably would have done so had the Cherokee not stayed out of the fray.

But while the imperialists, the mercantilists, and the businessmen of England were pressing the King to start a new colony to be located in Georgia, it was a humanitarian cause led with missionary zeal by one James Edward Oglethorpe that got it going. Oglethorpe persuaded the King to charter the colony, not as a royal province, but as a private company with three purposes: 1. to provide a haven for worthy people in England's dreaded debtor's prison; 2. to increase trade and wealth in the realm; 3. to provide a barrier to defend South Carolina and the provinces farther north, from the Spanish. While these three reasons applied to and were popular among Englishmen generally, another reason for the colony proved popular among the masses. It was pointed out that opportunities would be offered "to poor Protestants" seeking a haven from European persecution. Thus,

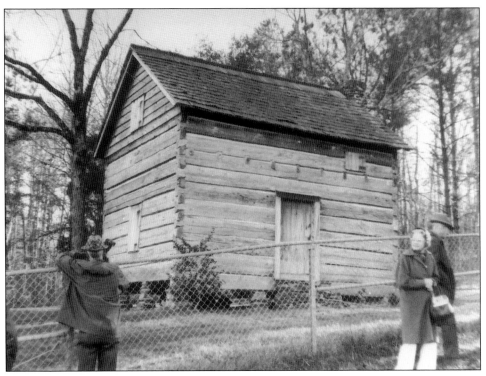

Seen here in 1977, this log fort, or blockhouse, known as Fort Yargo is located several miles southeast of Winder. It was built in 1792 by the Humphries brothers to protect early settlers from Indians. Fort Yargo State Park takes its name from this historic structure.

although the first settlers were English, there soon arrived a diverse group that included Scots, Irish, French, Salsburgers, Moravians, Swiss, and Welsh.

The social and humanitarian ideals of the Trustees were evident early on. To discourage the growth of large plantations, land grants were limited to 500 acres. Rum was prohibited. A representative government was not provided for because colonists had little experience in politics. And slavery was prohibited, even though it was allowed in English royal colonies.

To encourage people to come to Georgia, the Trustees offered each man free passage, 50 acres of land, and a year's support for his family until he could start making his own way. Or, if he could pay his own way over, he could get 500 acres tax free for 10 years.

As W. Stitt Robinson said in his study of the Southern colonial frontier: "The lofty ideals the trustees hoped to implant in Georgia were no match for the urge to benefit from the vast area of land available and the demands of the settlers to have the same opportunities as other American colonists."[1] The restrictions on landholding were changed from 500 to 2,000 acres in the early 1740s. In view of the value of rum in the Indian trade, as well as for sale to the colonists, the Trustees relaxed enforcement of alcohol prohibition in 1742. The antislavery law

was repealed in 1750, although several slaves were already in the colony at that time. And finally, in 1752, the trustees yielded control, and Georgia became a royal colony.

Coastal Georgia's frontier era ended around 1750, and a plantation culture began similar to that in the coastal Carolinas and Virginia. With the lifting of the slavery restriction and a declining threat from the Spanish, large plantations were developed along the coast and on the coastal islands, and the population began a rapid growth. In 1753, the population of Georgia was listed as 2,300 (1,900 whites and 400 blacks). In 1773, just before the American Revolution, the population was listed as 33,000 (18,000 whites and 15,000 blacks).

The frontier moved inland, but not far. Augusta was laid out in 1735 and became a trade center, for boats could move that far up the Savannah River. In 1740, the Cherokee, hoping to encourage more trading in furs, allowed the opening of a path for saddle horses between Augusta and the headwaters of the Savannah River. Indian trading trails connected Augusta to Charleston as well as Savannah. As the American Revolution began, the crude maps of the time listed the mountains of Northeast Georgia as "Cherokee Country," for it was still an unpopulated, rugged frontier.

While the English settling coastal America knew very little about inland areas beyond navigable rivers, the Indians had full knowledge of a north-south route called the "Warriors' Path," which ran along the eastern edge of the Appalachian Mountains. It was controlled by the Iroquois, and this ancient route had long been used by their tribes to come south to trade, or their warriors to come into Virginia and North Carolina to make war on other Indian tribes.

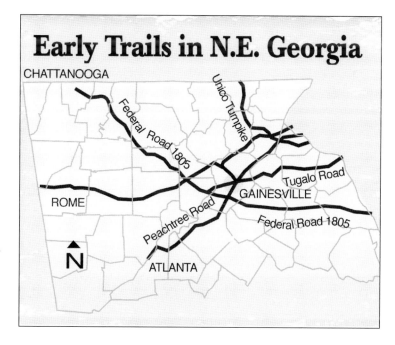

The main trails feeding settlers into Georgia's mountain area from the Great Wagon Road were the Federal Road, Unicoi Turnpike, Peachtree Road, and Tugalo Road.

In 1744, the English signed a series of treaties with the Five Nations of the Iroquois for the use of the path. After 1744, the English took over the land itself, and Parke Rouse Jr., in his book *The Great Wagon Road*, says the Warriors' Path became "the principal highway of the colonial back country" and "an important chapter in the development of a nation."[2]

This backcountry road became known as "the Great Wagon Road," or "the Great Philadelphia Wagon Road." It was down this heavily-traveled route that vast numbers of English, Scotch-Irish, and Germans came to claim their own farms and create a new life in the New World. Rouse states the following:

> The endless procession of new settlers, Indian traders, soldiers, and missionaries swelled as the Revolution approached. "In the last sixteen years of the colonial era," wrote the historian Carl Bridenbaugh, "southbound traffic along the Great Philadelphia Wagon Road was numbered in tens of thousands; it was the most heavily traveled road in all America and must have had more vehicles jolting along its rough and tortuous way than all other main roads put together."[3]

Thus, mountainous Northeast Georgia was not settled by wealthy planters from Charleston or Savannah. It was mainly settled by less well-to-do people who landed on this continent in or near Philadelphia and made the long trip south along the rough, frontier route called "the Great Wagon Road."

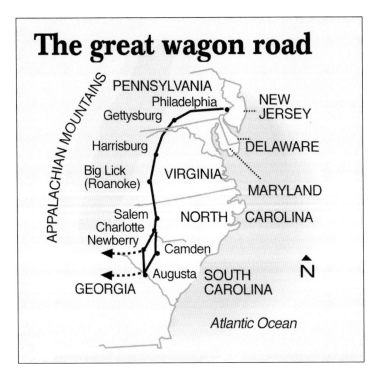

The great wagon road

The Great Wagon Road was the "principal highway of the colonial backcountry." Most settlers came to Georgia's mountain region via this route.

3. THE FRENZIED SEARCH FOR AFFORDABLE LAND

America was populated by people looking for personal and religious freedom—that is true—but they also were looking for economic opportunity and an economic structure that allowed them to control their own destiny. In most cases, the measure of success was not money; the measure of success was land. Most American settlers were coming from Europe, and in Europe, wealth and recognition were measured by land ownership.

The coastal regions of the Southern United States were settled, almost exclusively, through royal grants, by trading company promotions, and by wealthy European families. Enterprises were formed that established cities, businesses, plantations, and new ventures (such as rice growing or silk culture) that showed promise of producing great wealth for people back in Europe.

During the 1700s, however, a great land rush took place in America that had a distinctly different pattern from the plantation culture of coastal America. Historian W. Stitt Robinson noted, "The pattern of settlement reflected the distinction between the small farmer of the Piedmont and the planter with slaves from the low country."[1]

The people who came to America from Europe seeking freedom and a small farm were honorable people, but were neither wealthy nor well connected. Many were escaping the well-documented repression in Europe. A large percentage who came south landed at mid-America ports or the Chesapeake Bay area, and since the cheapest land was away from the coast and farther south, they traveled the path known simply as "the Great Wagon Road," or "the Great Philadelphia Wagon Road," depending on whose map they acquired. This road left Philadelphia toward Baltimore, continued west through Pennsylvania, turned south to Roanoke, on to Salisbury, North Carolina (where it tied in for a while with the Occaneechee Path), then to either Charlotte, North Carolina, or Ninety Six, South Carolina, and finally to Augusta, Georgia.

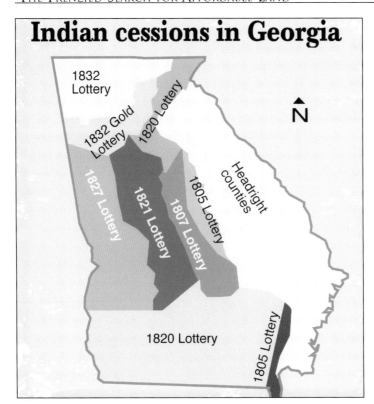

Georgia became available for settlement when Indian tribes ceded land through treaties, and most land was parceled out through land lotteries.

It was the frenzied search for affordable land down this frontier highway which opened up inland Virginia, the North Carolina Piedmont, western South Carolina, and eventually North Georgia. But, it took several decades for the frontier to reach the mountains of North Georgia, and settlement in this area was still illegal, and very sparse, when the Revolutionary War was fought. The migration came in "successive waves." Historian Turner stated, "Stand at Cumberland Gap and watch the procession of civilization, marching single file: the buffalo following the trail to the salt springs, the Indian, the fur trader and hunter, the cattle raiser, the pioneer farmer—and the frontier has passed by."[2] North Georgia was still in the fur trader era before its land became available for frontier farming in the early 1800s.

In an article in *Native Peoples* magazine, Jack Rutherford says, "The tall skyscrapers and tremendous corporate wealth of cities such as New York arose from the profits of the fur trade, which depended entirely on the skills of American Indian men to trap animals and the technology of Indian women to cure and prepare the pelts." During the pre-Revolutionary period, when settlers were claiming rolling farmland in Virginia, and North and South Carolinas, traders (many of them Scottish) were buying pelts from the Indians of Appalachia. As traders traversed the mountain area, the maps became more accurate. In 1715, Major John Herbert, a British commissioner of Indian Affairs, explored

and mapped the entire Cherokee nation. There was an ever-increasing stream of white men through the territory: traders, hunters, military scouts, and Christian missionaries. From time to time, Indian tribes would mount opposition to the encroachment of the white man, but the Indians had found they could trade furs for all kinds of exciting things. The advantages of trade overruled their instinctive distrust of the white man, and the Indian country opened up.

In October 1816, traders from Indian territory crossed the border into South Carolina (mostly from Augusta, apparently) with 2,087 dressed buckskins. At that time, an Indian could get a gun for 30 buckskins; an axe for 4; a hatchet for 2; three strings of beads for 1; and a bottle of rum for 1. Trade was lively. The relationship between traders and Indians in Northeast Georgia was cordial and peaceful, but as settlers came into North and South Carolinas, brutal Indian wars broke out.

Augusta, the location of a trading event among the Indian tribes prior to the discovery of America by the Europeans, was a frontier trading post where merchants, primarily from Charleston (or Charles Town at that time), could barter with traders, as well as with both the Creek and Cherokee Indians.

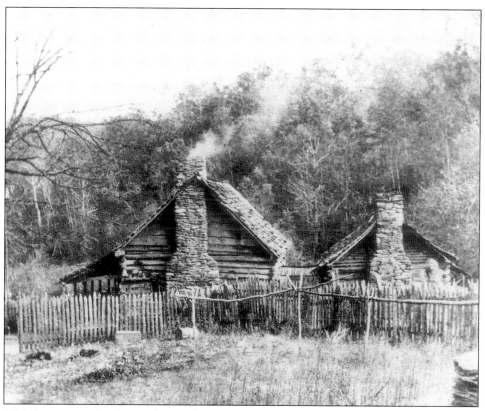

This is an example of an early Northeast Georgia settler's cabin. The materials for building this homestead came from nearby. Note there are no windows built into this residence.

Then, the Cherokee inadvertently opened up their territory in the mountains of Northeast Georgia for travel, and eventually to settlement. Hoping to encourage more trading in furs, the Cherokee allowed the opening of a path for saddle horses between Augusta and the headwaters of the Savannah River, and allowed free access to the white man.

Although Savannah and the coastal culture was the foundation for Georgia history, the rugged settlers who came into the mountains had more in common with the people coming down the Great Wagon Road than with the more traditional, more civilized English settlers on the coast. Whereas Oglethorpe insisted on following traditional English law, which said a treaty was needed to move onto lands belonging to an Indian "nation," Georgia's mountain folk figured Oglethorpe's "deed" from the King was all that was necessary for a person to be granted clear title to a piece of Georgia land.

One of the first orders of business for Oglethorpe was to sign a treaty with the Indians. Franklin Garrett, the late Atlanta historian, said, "The process of territorial expansion in Georgia, whereby all of the land in the state was acquired from the Indians, took one hundred and two years, that is, from 1733 when the Creeks made a treaty at Savannah with Oglethorpe, to 1835, when the Cherokees

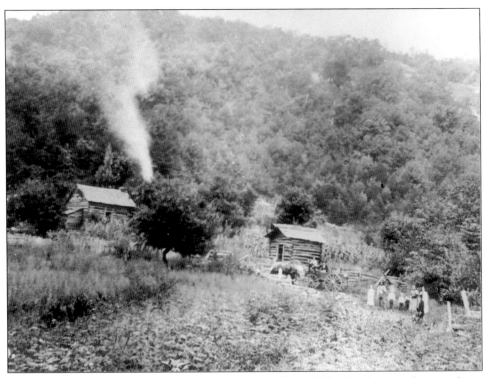

Cotton and corn were planted by early settlers on hillside fields like these on this Northeast Georgia farm. The seven children in this family helped with a variety of chores and tasks around the farm.

James Edward Oglethorpe founded Georgia in 1732 under a charter from King George II. Although coastal Georgia developed inland as far as Augusta, most settlers of the upper piedmont and mountains came down the Great Wagon Road. (Courtesy Georgia Department of Archives and History.)

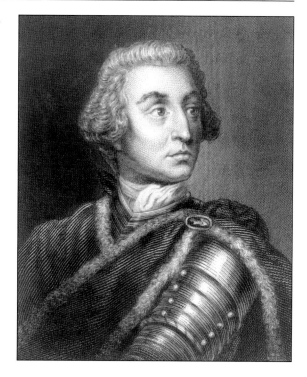

ceded the last of their territory in Northwest Georgia."[3] Georgians who had won a piece of mountain land in a Georgia lottery saw no reason to wait around until somebody signed a treaty with some Indian tribe.

The United States government agreed with Oglethorpe and English law: there should be a treaty with the proper Indian tribe before a state could grant clear title to a landowner. It was one of the first serious arguments between Georgia and the federal government over state's rights.

Oglethorpe had signed treaties in 1733, 1739, and 1763 with the Creek Indians making it legal to settle in certain parts of Georgia. The cession of 1773 was the last signed by the British, and it was with both the Creeks and Cherokees. The Creeks ceded a large portion of Eastern Middle Georgia, and the Cherokee ceded piedmont land in Northeast Georgia. The Cherokee cession included the modern-day towns of Hartwell, Danielsville, and Elberton, but not the mountains of Northeast Georgia. At the beginning of the Revolutionary War, modern-day Hall County and the other counties to the north of Hall in the mountains were in Cherokee Indian territory, and there was already debate about who held title to this entry into the Blue Ridge Mountains.

Then, in 1777, during the Revolutionary War, the State of Georgia threw open the land from the Cession of 1773, and Northeast Georgia's land rush was finally underway. Families swarmed in from other points in Georgia, from Virginia, and the Carolinas, and when the first U.S. census was taken in 1790, this new territory had a population of 31,000 people.

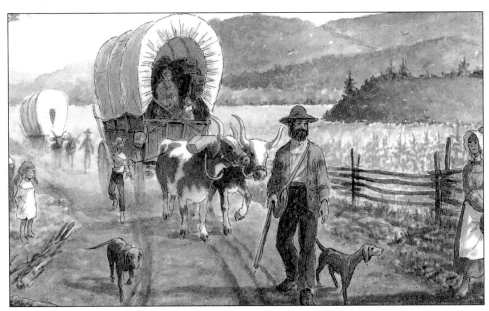

Settlers came into the valleys of Georgia's mountains along the Unicoi Turnpike. (Illustration by John Kollock.)

The end of the Revolutionary War brought drastic changes in land policy in Georgia. The state confiscated the property of the English Tories, those who had remained loyal to the King, insisting they were the enemy and not worthy of American land. Although there was no Tory land in Northeast Georgia, the action set an important precedent, and the American pioneers—if they needed an excuse—insisted Indian country no longer belonged to the Indians, but to Georgia. After all, both the Cherokee and the Creeks had chosen to fight on the side of the English. The Indians had energetically killed Americans, and their side had lost. Settlers began to encroach on Cherokee land, taking cattle in to graze and moving up the river valleys to settle on the rich bottom land. Sporadic fights between Indians and whites broke out. The white man wanted farming land of his own that he could put a fence around. The Indian wanted all land left open for hunting and tribal activity with no fences. Things got brutal.

The Treaty of Hopewell brought peace between the Indians and Americans in 1785. Even though it contained no specific provision for land, its practical effect was to let stand any land already settled. And the line between Indian country and Georgia's Franklin and Jackson Counties became "the Ridge," the "Standing Peachtree Trail"—that is, the Eastern Divide, the point at which water on the east flows to the Atlantic Ocean and on the west to the Gulf of Mexico. The Standing Pitch-Tree Trail (to use the proper term) runs from Atlanta along a ridge through Hall and Habersham Counties. However, people continued to come, and the general mood supported the complete expulsion of the Cherokee from the state.

Then, a rapid series of agreements changed everything. In 1802, the Creeks ceded some more land in Middle and South Georgia, but of more importance to North Georgians, "the United States government made an agreement with Georgia to the effect that all Indian titles within the territory of the state would be extinguished as soon as it should become practicable."

In 1803, the United States was given the right to build the Federal Road across Cherokee territory to East Tennessee, and a formal treaty was signed in 1805. The Unicoi Turnpike was delayed by the prelude to the War of 1812, but was cleared in 1813, allowing a major route through the mountains.

Also, in 1803, the Georgia Legislature passed a "Land Act" to minimize land speculation. Anticipating that the Indians would cede more land to Georgia, a system of lotteries was established to distribute the newly acquired land directly to Georgia citizens. This would keep speculators out of the picture—an amazing act in an era when in many states politicians and land speculators were the same people. The news of free, or at least cheap, land renewed the constant stream of hopeful settlers into Georgia—not only from the non-plantation areas of the East Coast, but from areas all over the nation. The lottery system was in effect from 1805 until 1832.

In 1804, an unusual cession was made by the Cherokee involving a strip of land 4 miles wide running from present-day Gainesville to Clarkesville. It was known as the "Four Mile Purchase," or as "Wafford's Settlement." There is the possibility, of course, that small "purchases" of this type might have set a new, more peaceful pattern had not trouble developed leading to the War of 1812 with England.

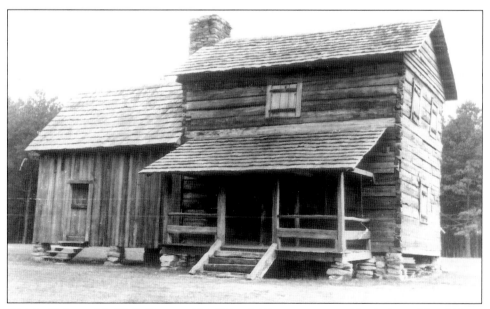

Originally located in Hall County, Chief Vann's Tavern was moved log by log to New Echota in Gordon County when Lake Lanier was formed.

The English, using Chief Tecumseh, stirred the Indians against frontier settlements all the way from Canada to Florida. Although the Cherokee were relatively quiet, the Creeks were not. General Andrew Jackson came into Georgia and then Alabama to quell the Indian uprising and put a stop to the frontier violence.

History reports fully on the War of 1812, but probably the biggest step toward settling who had the right to the mountain land of Georgia came with the lesser known Compact of 1812. The Compact of 1812 was an agreement between the U.S. government and the State of Georgia in which Georgia ceded to the United States all its western claims (from the Alabama border all the way to the West Coast). In exchange, Georgia got title to the Indian lands "lying within the limits of that state." In other words, Georgia gave up all the land the King gave Oglethorpe west of the Alabama border in exchange for clear title to all the land in the rest of Georgia. After this, pressure on the federal government from the citizens of Georgia was relentless to "extinguish" the Indian titles. After all, the U.S. government had agreed that North Georgia belonged to the State of Georgia, not the Cherokee.

In 1817, the Cherokee ceded a tract of land included in the modern-day counties of White, Lumpkin, Dawson, Forsyth, and Cherokee. In 1818, the Creeks relinquished title to their northernmost holdings, and some of this land is included in Hall, Walton, Gwinnett, and Habersham Counties. In 1819, the Cherokee ceded a large tract of land that lies within the present boundaries of

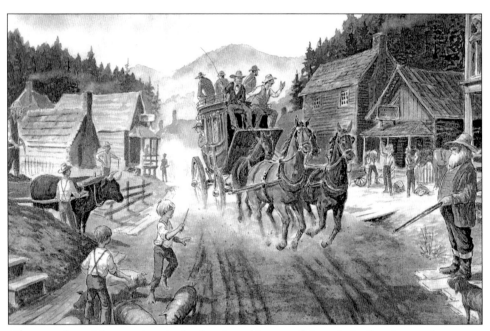

The stage from Athens arrives in the frontier gold town of Auraria in the nineteenth century. (Painting by John Kollock.)

Major Barber received these orders to raise a militia company in Hall County. Their duty was to remove the American Indians from Georgia.

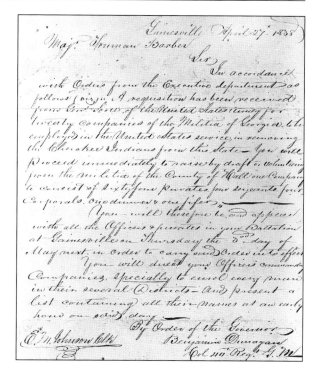

Hall, Habersham, White, Lumpkin, Dawson, Union, Towns, and Cherokee Counties. Then in 1821, the Creek cession at Indian Springs gave to Georgia the land south and west of Hall County, including the land where the City of Atlanta now stands. For all practical purposes, the land wars were over, although they would not be finally settled until December 29, 1835, when the Cherokee nation, at New Echota, signed away their last claims to land in Georgia—setting the stage for the "Trail of Tears."

Settlers poured into North Georgia. Cherokee land in Hall, Habersham, Walton, and Gwinnett Counties was surveyed into land lots and distributed to lucky Georgians in the Land Lottery of 1820. Gainesville, rapidly developing as the trade center of Northeast Georgia, was chartered in 1821, and shortly thereafter, the population of Hall County was estimated at 5,000 people. It took 102 years to settle the Coastal Plain and Piedmont Plateau of Georgia, where the land was more desirable for farming. But when that land ran out, it took less than 20 years for the settlers to sweep across North Georgia's mountains.

The U.S. government removed the Cherokee Indians from the Southern Appalachians to Oklahoma, and most historians agree that it was a tragedy. But who was right and who was wrong, and how big a tragedy was it?

It would seem that this was a local event. North Georgia was the frontier in the early 1800s, and there was a great competition to see who would control the land; the Cherokee who had possession, or the new Georgians, the settlers, who wanted land for their small farms, or the gold diggers, who also were in the picture. But

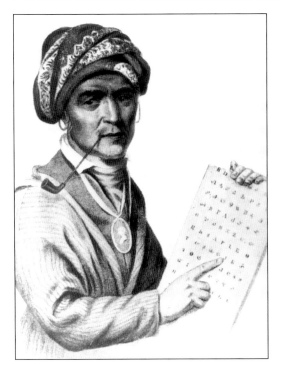

Sequoyah developed the Cherokee alphabet. He was born in 1770, the son of a white trader named Gist and an Indian mother.

this was not merely a local disagreement; before it ended with the "Trail of Tears," its primary players would include the President of the United States, the Chief Justice of the U.S. Supreme Court, the U.S. Congress, practically all the elected officials of Georgia, New England and East Coast religious groups, the editors of most American and some European newspapers, and the U.S. Army.

Did the Georgians have a legal case for removing the Cherokee from the state? They thought they did. There was ample precedent, for Northern tribes had been removed through treaties carrying names like Albany, Lancaster, and other towns. The Cherokee had sided with the British in the Revolutionary War, and lost, and thus deserved the same treatment as the Tories. The U.S. government had agreed that Georgia should have clear title to the land in its borders in exchange for land west of the Alabama border. Congress had passed the Indian Removal Act, and President Andrew Jackson had signed it. So far as the Georgians were concerned, it was not a matter of whether the Cherokee would go, but when. Not only that, Georgians felt this was a state's rights issue that should be decided in Georgia.

Those who supported the Cherokee felt they had a strong case, too. The Cherokee were the last of the Eastern Indians to be removed, and they had shown they were a civilized people, not savages. Missionaries had worked in Cherokee country, and the Cherokee not only accepted the white man's religion, but also his culture. Many were educated, some up East. Many had sizeable business interests. Probably most impressive was the fact the Cherokee had developed an alphabet, had a newspaper, and had a government patterned after that of the United States.

All this, and more, was considered proof that these were civilized people who should be allowed to have their own nation inside Georgia. Most of those who sided with the Cherokee felt this should be decided by the federal government. The case was complicated and emotional.

Historian Kenneth Coleman commented as follows:

> Most [Indians] supported their main Chief, John Ross, in his resistance to removal. More Scot than Cherokee, the able Ross had favored adopting white civilization and had himself become a prominent planter with many slaves, but he could not stem the white tide. Finally, in 1835, a minority faction of the Cherokees under Major Ridge, his son John Ridge, and his nephew Elias Boudinot signed the treaty of New Echota, agreeing to move to the west in return for $5 million from the federal government.[4]

The Cherokee still stalled, but in 1838, the U.S. government acted and the removal began— the "Trail of Tears" was underway.

One great debate remained, and it goes on among historians to this day: how many Cherokee actually died on the Trail of Tears? Government figures, taken from the census of those leaving and those arriving, indicated about 200 died in the camps and 300 on the trail—for a total of 500. Official figures would later show a count of 424 had died.

But a Doctor Butler, a medical missionary from Connecticut travelling with the Cherokee, insisted 2,000 had died in the camps and 2,000 on the trail—for a total of 4,000. This was the figure that became known in the Eastern United States, and that was generally accepted at the time. Author John Ehle noted, "How many Cherokees and their slaves died? The answer is a mystery, enhanced, complicated by decades."[5]

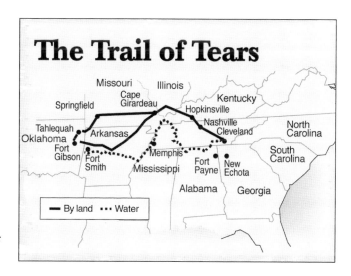

The Cherokee Indians, who held sway in North Georgia, were moved by the U.S. government from the Southern Appalachians to Oklahoma.

4. The Georgia Gold Rush

The people who settled North Georgia and started their own small farms were adventuresome but stable people. They were generally hard-working, God-fearing, family-centered settlers who hoped to earn personal freedom and economic success through a family farm. Then came gold, and there is something about gold that makes otherwise sane people do strange things.

There had been rumors of gold in Northeast Georgia, of course, since before the 1540 DeSoto expedition when Florida Indians told the Spanish the gold they were wearing came from "Apalacha," far inland. There is evidence the Indians used gold for jewelry and for trading.

Gold had been found in North Carolina. The first recorded gold mining in the United States came in Cabarrus County, North Carolina, in 1799, and by 1804, a good bit of mining was underway near Fayetteville. Every now and then, there would be a "find," or rumors of a find, but nothing commercially serious developed.

In 1828, several discoveries of gold took place in North Georgia, almost simultaneously. Probably the most widely reported was when Benjamin Parks went deer hunting just east of the Chestatee River, in what was then Hall County (but four years later became part of Lumpkin County), and kicked a rock. When he picked it up, it was solid yellow, and it is reported that he said it looked like the yolk of a hen egg. About the same time, a Negro servant of a Major Logan discovered gold in White County, near Loudsville. Enough finds took place that there was no doubt about it: there was gold in Northeast Georgia.

Word spread, first by word-of-mouth, and then newspapers throughout the United States picked up the news. Stories were told of people finding nuggets worth as much as $200, a princely sum in those days. And by 1829, America's first full-blown gold rush was underway.

The gold rush came at a time when there was question about who, if anyone, owned the land. This mountain area had just been ceded by the Indians, and

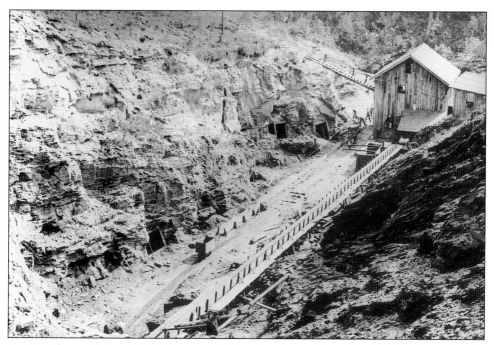

In time, the search for gold left the stream beds and took speculators into the Northeast Georgia hills and mountains.

Georgia was to take possession of the area in 1830, but the land was to remain in Indian hands until the State decided how to disperse it to individual owners. Gold fever swept up the East Coast of America, and literally thousands of people poured into North Georgia in what came to be called the "Great Intrusion." The May 1830 *Niles Register* reported 4,000 miners were working Yahoola Creek alone. Town names like Dahlonega and Auraria became commonplace on new maps of Georgia.

The Cherokee objected to the intrusion, claiming the land was still theirs, and the United States agent to the Cherokee sent army regulars in to remove the miners. The army would move in, catch some miners, and remove them, only to find many or more gold diggers in the same place the next day. To complicate things further, some Cherokee had also contracted gold fever. When the army moved the intruders out of an area where they were working, the Cherokee moved in. Clashes developed between the miners and the Indians, and to avert serious battles, the army attempted to forbid anyone from working the gold sites. That definitely didn't work. Chaos became the order of the day.

All this brought on some serious state's rights fights between Georgia and the U.S. government. Governor George Gilmer and the Georgia Legislature insisted that this was state land and the U.S. army had no right to exercise authority within its borders. The Indian Removal Act had recently passed Congress, so President Andrew Jackson agreed with Georgia, and the army was withdrawn.

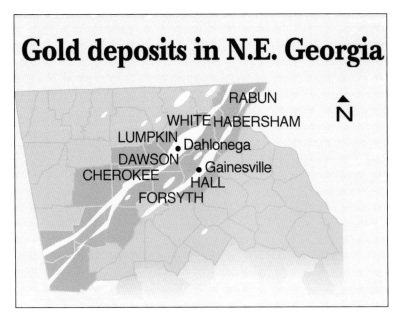

Gold deposits in N.E. Georgia

RABUN

WHITE HABERSHAM

LUMPKIN • Dahlonega

DAWSON

CHEROKEE • Gainesville

HALL

FORSYTH

N

Georgia's gold belt followed the mountain ridge pattern, northeast to southwest, but centered in Lumpkin and White Counties.

For at least two years, Northeast Georgia's gold country was a lawless frontier. The miners were called the "Twenty-Niners" and Governor Gilmer wrote this impression of them:

> Many thousands of idle, profligate people flocked into it [Northeast Georgia] from every point of the compass, whose pent up vicious propensities, when loosed from the restraints of law and public opinion, made them like the evil one in his worst mood. After wading all day in the Etowah and Chattahoochee Rivers, picking up particles of Gold, they collected around lightwood knot fires, at night, and played . . . at cards, dice, push pin and other games of chance, for their day's findings. Numerous whiskey carts supplied the appropriate aliment for their employments. Hundreds of combatants were sometimes seen at fisticuffs, swearing, striking and gouging, as frontier men only can do these things.[1]

Eventually, the State of Georgia got the land surveyed and the Cherokee land was dispersed to new owners in the Land Lottery of 1832. There were still many people who dreamed of personal and economic freedom through ownership of their own farm. The 1832 Land Lottery had 18,309 parcels of farming land, at 160 acres each, and 85,000 people signed up for that portion of the lottery. These were the people who simply wanted land of their own.

But the intensity of gold fever became apparent in the gold portion of the 1832 lottery. There were 35,000 parcels in that portion of the lottery, with 40 acres each, and 133,000 people signed up, hoping for quick fortunes from gold.

After the lotteries, law and order began to return, but there was still a problem to be solved. The Indian Removal Act of 1830 specified that the new owners of land could not take possession of it if Indians resided there. The Indians had to voluntarily leave, or be moved off by the government.

Pressure mounted as the white men moved in, either to claim their newly acquired farm or gold land. In late 1835, the Cherokees signed a removal treaty giving them $5 million and new lands in Oklahoma, and in 1836, President Martin Van Buren ordered Major General Winfield Scott into North Georgia with five regiments of regulars and 4,000 militia and volunteers. The "Trail of Tears" was underway, and 13,000 Indians were removed from their homelands in the North Georgia mountains and "escorted" to Oklahoma. With the Indians out of the picture, gold mining moved quickly from individuals panning for gold in mountain streams to business ventures.

One of the early investors in gold mining in North Georgia was famed U.S. Senator John C. Calhoun, of South Carolina. He bought the mineral rights to the land where Ben Parks found that first nugget, and the Calhoun mine was one of the first and biggest in the area. Calhoun was a frequent visitor to Dahlonega, and when local citizens proposed a branch for the U.S. mint in the area, he took up the cause in Washington. The U.S. government approved a branch mint for Dahlonega in 1835, and the mint went into operation in 1838.

Historians Rensi and Williams, in their book *Gold Fever*, reported that the Dahlonega mint coined over $100,000 worth of coins the first year of operation, and by the time it was closed at the beginning of the War between the States in 1861, it had produced almost 1,500,000 gold coins with a face value of over $6 million.

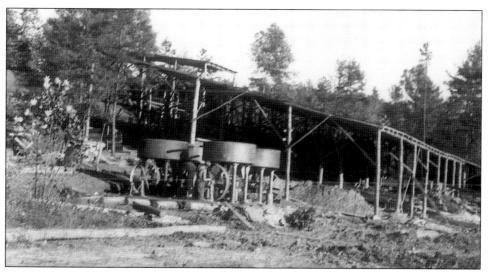

The Consolidated Gold Mine Company operated this mill and chlorination plant in Lumpkin County in 1913.

By the early 1840s, however, placer mining—that is, taking gold directly from streams and rivers by panning or other means—was beginning to decline. Most of the streams with adequate "color" to make a miner wealthy had been worked. As the miners began to work land above the streams, to cut the banks and dig in mineshafts, ownership of the land (or at least the mineral rights to the land) became imperative. No longer could a single miner wander up and down rivers and streams and pan for gold without regard for who owned the land. And as the area became more "civilized," the law required more respect for property ownership.

So, the type of gold rush which attracted hordes of people but took very little capital began to decline, and as vein mining replaced placer, mining companies began to form and the gold fever shifted from rugged individuals who came to hunt gold on their own to investors in faraway cities who were willing to risk big money in hopes of big returns.

The State of Georgia began to grant charters for companies with such names as Cherokee Mining Company, Chestatee Mining Company, and Lumpkin County Mining and Manufacturing Company. Gold was becoming an industry. And again, probably the most famous of the business ventures was the John C. Calhoun Mine, owned by the South Carolina senator. As the companies bought equipment and developed veins, mines came to be identified with names like Crown Mountain, Battle Branch, the Gordon Mine, Barlow, Findley, and Whim Hill.

In this view of the flume line at Dick's Creek, these troughs carried water, sometimes for miles, to aid in gold mining.

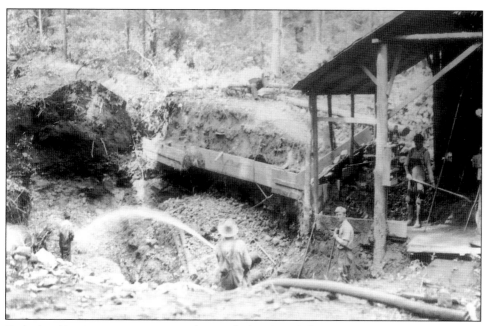

In hydraulic mining, water was used to wash dirt downhill so that gold ore could be isolated and taken to stamp mills.

Many of the individual miners, those unable to make a living, let alone get rich, began to drift away from the gold fields of Northeast Georgia. Then, in 1849, electrifying word came of a major gold find at a place called Sutters Mill, in California. And, just as they had come to Dahlonega in 1829, they left for California in 1849. There is a story of long standing about a leader of Dahlonega, Dr. Matthew F. Stephenson, standing in the heart of the town and pleading with the miners not to go to California. As he pointed to the mountains surrounding him, he made his memorable plea: "Thar's Gold in them thar hills." They went anyway.

The mining companies began to tap richer veins, but this required more expensive and sophisticated equipment. Sinking shafts straight down would require equipment to haul the material to the top. Then, the ore would go into stamping mills, where it was hammered into a fine powder. It would then be passed over a plate of "quicksilver" (mercury), to which the gold would adhere. And then the quicksilver and gold were separated by heating in a retort vessel.

As the easy veins were depleted, the colorful era of gold in North Georgia ended, but gold continued as a solid industry for the next 20 years. Then came the Civil War and the mint was closed down, and little by little the mines went out of existence, unable to make a profit as the richness of the gold ore declined.

After the Civil War, many efforts were made to renew gold mining in the region. Many companies were formed. Stamp mills were scattered throughout the gold country. Barges were built to work the rivers, huge things that were

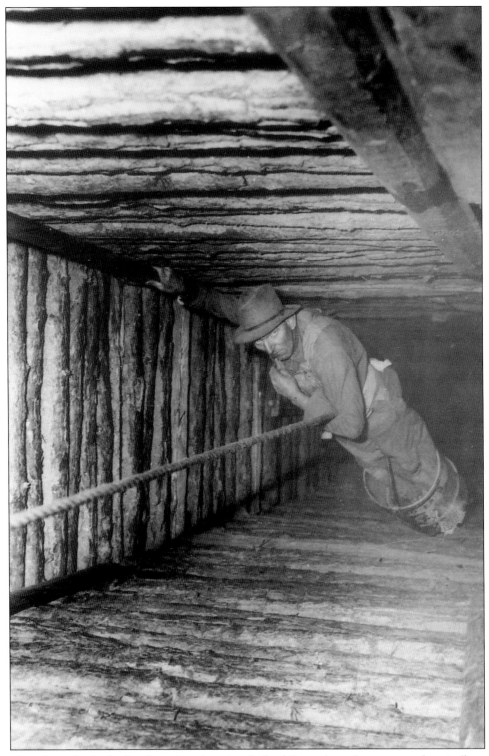

A worker rides the bucket down into the mine shaft while workers above operate the windlass.

literally floating factories. A lot of money was raised, from all over the United States and probably from some foreign countries, too, and a lot of mountain people got good paydays from the money plowed in by investors hoping to hit the mother vein—or at least find gold. As late as the 1930s, stock was being sold in supposedly "new finds."

Some of the mines, it turned out, had been "salted." Unscrupulous people would pan enough gold particles to load a few shotgun shells with gold dust. Then, they would shoot the gold into the walls of a "new find" mine, and call in an assayer. The assayer's report, sure enough, would report there was gold in that mine. The mine owner would form a corporation and sell stock to investors. The original owners would then drain the money out of the corporation before it was declared bankrupt. Almost everybody knew the high risk involved, but people invested anyway. Such is the allure of gold.

Every now and then, gold fever has been renewed in "them thar hills," but thus far, gold has not been renewed as a viable industry.

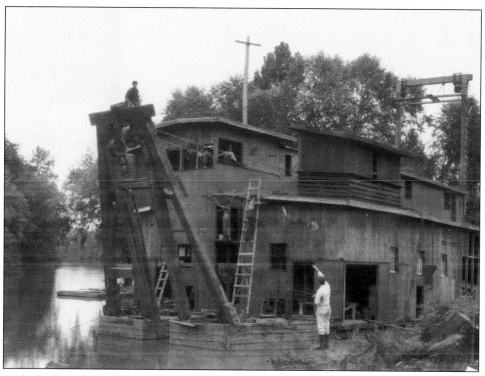

A dredge boat for recovering gold from river beds is seen here working on the Chestatee River near Dahlonega in 1915.

5. LIFE WITHOUT RAILROADS

From 1840 to 1860, the economy of Northeast Georgia settled down and stabilized as the South headed reluctantly toward the War between the States. Settlers built their farms; the prospectors panned for gold; companies were formed to extract gold mechanically; and wealthy plantation owners, merchants, and ship owners invested and built summer homes in the mountains. Gainesville developed as the trading center of Northeast Georgia, drawing goods mostly from Augusta through Athens. Smaller trading centers developed farther in the mountains.

Even so, this area the Indians called "the Enchanted Land" was still a raw, rough-and-tumble frontier compared to most of the rest of the world. While the people of the mountains were trying to become civilized, the more civilized sections of the world were focused on trade, and especially world trade.

In Europe the synonym for wealth was "as rich as a West Indies planter," a reference to the sugar plantation owners of Jamaica and the West Indies. After the War of 1812, cotton was scarce and went to the unheard of price of 25¢ per pound. The textile mills of England were desperate for cotton, and the Southern portion of America was ideally suited to cotton production. For many other reasons, too, European traders were excited about America and willing to invest and trade here.

Here in America, exporters were learning that great wealth was possible by trading in products brought from the Midwest (Ohio, Indiana, Illinois, etc.)—not only furs, but livestock and grain products. There was one major barrier to the movement of products from the Midwest to the East Coast: the Appalachian Mountains, from Upstate New York to North Georgia.

Methods of transportation were being developed across the Northern end of the mountains in the early 1800s (roads, canals, and then railroads) to feed products to Northeastern ports: New York, Boston, and Philadelphia. From the beginning, they were filled with products moving east, and of course, with settlers and goods moving west.

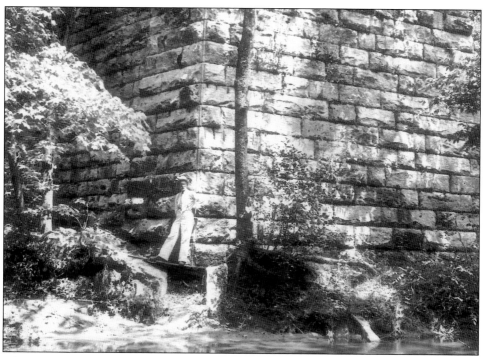

This 1932 scene captures the base of a large unused pier for a bridge over Warwoman Creek for the Blue Ridge Railroad, which never made it over the mountains.

Roads across the Appalachians in Virginia, North Carolina, and Georgia were virtually non-existent. When the Federal Road in Georgia was opened through Cherokee country (coming near Flowery Branch as its entry point) in 1805, it was almost immediately filled with drovers and their herds of cattle, hogs, and even turkeys, headed for Charleston and Savannah.

A great competition developed between businessmen in the Northern ports (especially New York) and those in the South (mostly Charleston) about which city would be the dominant world trading port of North America. Charleston had some inherent advantages: it was an all-weather port, and it had steady shipping volume from nearby export products like cotton, tobacco, rice, and timber.

In 1819, a group of Savannah businessmen got the attention of the trading world. They sent the first steam-powered ship across the Atlantic Ocean. Shippers were quick to recognize that faster ships, larger loads, and routes not dependent on the trade winds could revolutionize world trade. At the same time, too much of the ship's cargo space was needed for wood for the boilers, and shippers were not comfortable putting their cargo on ships with big boilers aboard, wondering what would happen to those fire-burning rigs in rough seas. They were ahead of their time, and the tall American clipper ships continued to dominate shipping.

In all this jockeying for economic advantage, the ports of the South, from Norfolk to Charleston to Savannah, had some strong advantages. But the ports of

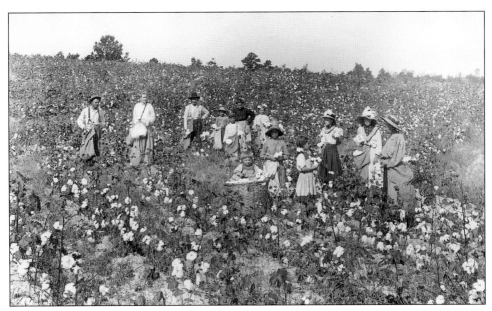

In both the nineteenth and twentieth centuries, cotton picking was done by hand and brought out all members of the family, as this photograph reveals.

the North, from Boston to New York to Philadelphia, had two aces in the hole: first, they were further developed industrially, and second, they had access to the exportable products of Middle America through existing canals and railroads. The port cities of the South, it appeared, had only one barrier to overcome if they were to become the dominant world trade centers of America: an easy and economical way to get goods from the Midwest to the Southern seacoast.

A group of Charleston businessmen, including Robert Y. Hayne and John C. Calhoun, took up the challenge and began promoting a railroad from Charleston to Louisville and Cincinnati, on the Ohio River. The State of South Carolina approved $5,000 (a major sum at that time) to hire surveyors to find a suitable route over the mountains. Calhoun had enough capital to make the project attractive, much of his money coming from his gold mine in Dahlonega. But also, railroad fever was rampant throughout the United States in the early 1800s, and this project caught the fancy of investors all over the country. The question in the South was: what route would the railroad take? Towns on the railroad would likely become thriving business centers. Those off the railroad, backwater.

Georgia's business leaders had not been particularly interested in the railroad boom, but when a "railroad convention" was held in Knoxville in 1836 to discuss the Charleston to Cincinnati railroad, Georgia sent 55 delegates. What they learned immediately got their attention: Georgia had shown no interest in the Charleston railroad project, so it had been left out of the plans entirely. Governor Lumpkin warned the legislature: " the apathy of Georgia . . . is pregnant with the most fatal consequences."[1]

When it became apparent that Georgia could not "divert" the Charleston project so that the railroad would run through Georgia, a convention was called for Macon in November. Delegates to this gathering recommended a railroad be built at state expense to connect Chattanooga and Atlanta, thus completing a link with coastal cities and the American Midwest. Lines were already in place from Charleston to Augusta, and Augusta toward Athens and Decatur.

The legislature met the same month, and William Washington Gordon, a legislator from Chatham County and president of the Central Railroad Company, introduced a bill that created the Western and Atlantic Railroad of the State of Georgia. The bill stated that the railroad would run from "some point on the Tennessee line . . . at or near Rossville" and ". . . cross the Chattahoochee River at some point between Campbellton, in Campbell County, and Wynn's Ferry in Hall County."[2]

The surveyors started their work with specifications for a grade not over 30 feet per mile, and curves would be limited to a radius of 1,000 feet. They determined the area of most difficulty would be between the Chattahoochee and Etowah Rivers. From the Etowah to Rossville, they could travel the valleys lengthwise.

Six possible routes across the Chattahoochee were identified. The northernmost route, near present-day Gainesville, was very appealing. It was the shortest and most direct route from Augusta to Chattanooga and apparently received a lot of attention. But for topographical reasons, all the routes except Pittman Ferry (near Norcross) and Montgomery Ferry (at present-day Atlanta) were eliminated. Eventually, the engineers chose the southernmost crossing point, located at Old Fort Gilmer and the Standing Peachtree, and in 1837 they drove a stake there and called it Terminus. The engineers had estimated this route would cost $18,000 a mile less than the other route. "Terminus" eventually became known as "Marthasville," and then as Atlanta. With the railroad, as with early settlers seeking farming land, Northeast Georgia was bypassed because of its rugged terrain.

This scene shows work taking place at a cotton gin at Gillsville in 1935.

Across America, the railroad boom went unabated. Many plans for railroads in Northeast Georgia were proposed, and some preliminary work started, but it would be almost 35 years, in 1871, before Northeast Georgia got its railroad from Toccoa to Gainesville to Atlanta.

While mountainous Northeast Georgia was on the economic sidelines without a railroad (or decent roads of any kind, for that matter), the rest of America was moving forward. Settlers were pushing across the Great Plains. Heavy industry was developing in the North. The plantations of the South with their cotton, tobacco, sugar, and rice—but especially cotton—were gaining immense wealth from world trade.

But, a major regional division was developing between the industrial North and the agrarian South. The debate was about slavery and states' rights. For the frontier settlers of mountainous Northeast Georgia, the debate over slavery was not high on their list of priorities.

Several counties—Hall, Habersham, and others—were just being formed from Cherokee country when the first serious conflict came in the United States over slavery. In 1819, a national debate broke loose over whether Missouri would be admitted to the Union as "slave or free" state. After the Missouri Compromise, the national debate quieted down. The issue was still important, of course, for plantation Georgia, but promotional brochures for some North Georgia towns noted that they were "above the Negro belt." They also noted that the Indians had been moved out, and that now it was safe to settle in rural areas. The settlers on the frontier in mountainous Northeast Georgia were interested in, but isolated from, the rest of the world. They were busy doing their own thing, and without a railroad, they were not deeply involved in national or world trade or politics.

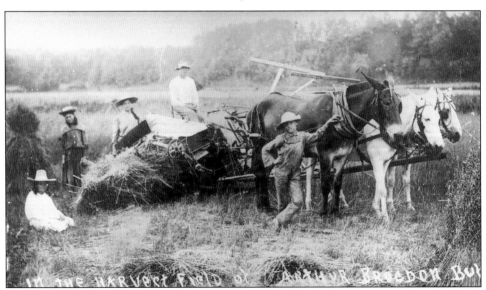

These workers had the advantage of a "modern" harvester, c. 1910.

As the intensity of the national debate over slavery and states' rights reached a fever pitch, the people of Northeast Georgia began to take sides. For the most part, they were not in favor of slavery and they certainly were not for withdrawing from the Union. At the same time, they were pragmatic enough to realize that much of the South's economy would be destroyed if slavery were abruptly abolished, and that like it or not, Northeast Georgia was a part of the South and would be affected. The South was not totally united. Neither was the North, for that matter.

Arthur Cecil Bining, in his 1943 book *The Rise of American Economic Life*, provided an unflattering, but probably accurate, picture of how Georgia's mountain people fit into the pre-Civil War culture:

> The plantations with their mansions, slave quarters, barns, storehouses, fields, orchards, and gardens were dependent, more or less, upon the West as well as on the farms of the South for certain agricultural products and meats, and upon the North for manufactured goods. Every phase of life in the South was under the domination of the plantation system, although in 1860 only about 383,000 [individuals] out of a population of 8,000,000 owned slaves in the plantation states, while less than 2,500 planters owned 100 or more slaves each. It was this latter group that largely controlled the South. About 1,000 families received more than $50,000,000 of the total income of the South compared with about $60,000,000 for the remaining families. The wealth and power of the entire section were in the hands of a few.
>
> Between the small number of the important planter class at the top of the social scale and the Negro slaves at the bottom were several other groups.
>
> The lesser planters and middle class farmers, who possessed from five to twenty-five slaves, together with the professional men and merchants of the towns and cities, who usually held one or more slaves as servants, were in sympathy with the ideals of the plantation system and provided the most vigorous defenders of southern civilization. The skilled workmen, yeoman farmers, and small tradesmen usually gave support to the ruling order.
>
> Another class of southern society, separate from the rest and with little or no contact with slavery, were the white inhabitants of the mountain areas of Virginia, the Carolinas, Georgia, Tennessee and Kentucky, who for the most part were small farmers. Still another group were the poor whites, low on the social scale. They were often squatters on the poorest lands, but usually inhabited the pine barrens of the low country, the sand hills farther inland, or remote mountain districts. Known by such names as "hillbillies," "cracker," "sand hillers," and "red necks," their existence was aggravated by poverty, hookworm, malaria, corn whiskey and a poor diet. They hated the ruling class as well as the Negro with whom they were forced to compete.[3]

The period leading up to the War between the States was an important but unspectacular time for Georgia's mountain area: counties were formed; towns chartered; land lines were drawn and property lines settled; farms were established; and businesses formed. The settling and civilizing of Northeast Georgia can be chronicled by the need for local governments, and thus the formation of new counties. Fast-growing Hall and Habersham Counties were created in 1818; Rabun in 1819; Cherokee and Union Counties in 1832. A stately courthouse was built in Dahlonega in 1836. Still in use as the Dahlonega Courthouse Gold Museum, it is the oldest existing public building in North Georgia. The next year, 1837, the U.S. Mint building was also constructed in Dahlonega.

As more settlers moved into the mountainous area, a second wave of counties was formed in the 1850s from Cherokee land that had previously been assigned to other counties: Fannin in 1854; Towns in 1856; and Dawson and White in 1857. It was a time when hardy pioneers turned their new land from a lawless frontier into a reasonably good, civilized place in which to live. And even though they did not have an overwhelming interest in the slavery issue, they were about to get caught up in it.

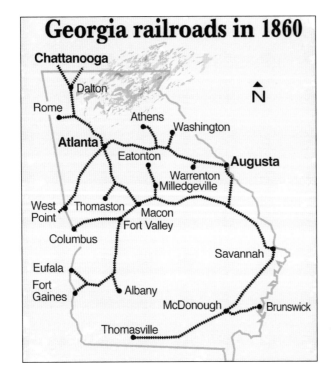

Georgia had a thriving network of railroads just prior to the Civil War, except in the mountains of Northeast Georgia.

6. Economic Disaster: The War between the States

The coming of the Civil War changed everything. Northeast Georgia was not an area of plantations and slaves, far from it. Although there were some slaves in the mountain area, most were domestic or personal helpers; few were used as field hands. They were a part of life, but were not vital to the success of businesses or farms. In fact, had the slave issue been the only disagreement between North and South, Northeast Georgia possibly would have stayed with the Union.

But there had been a running battle between Georgia (several other states, too) and the federal government from the beginning. Pennsylvania's "whiskey wars" were a battle insisting that the federal government did not have the power to tax whiskey made in Pennsylvania. Georgians didn't like the pushy federals telling them how to handle their Indian affairs, either.

The people of the United States still had a strong memory of the English king as the unchallengeable dictator, when rulings were handed down from "on high," and they were very protective of their "state's rights." But on issue after issue, the question was "where was the line?" What power belonged to the Union and what to the states? Debates were lively, creating enemies of friends and splitting families.

The naming of Union County, in far Northeast Georgia, sheds light on the intensity of the debate between those who favored a strong Union and those who wanted great power left at the state level. Union County was formed in 1832, well before the Civil War, and there was hot debate in the area, as well as in the legislature, as to whether the county government should have a strong Union credo or lean toward state's rights ideas. When the naming of the county came up for consideration at the state legislature, the new representative from that area is reported to have said as follows: "Name it Union, for none but Union-like men reside in it."

At the beginning of the Civil War, the people of the mountains were in a bind. Although they did not want a Union that could send down dictates from "on

The soldier on the Confederate monument on the square in Gainesville is fondly referred to by local residents as "Old Joe."

high," neither were they enamored of slavery. And although they had misgivings about the plantation system, they feared that if the cotton economy collapsed, it would take them with it. After all, cotton was the primary income-producer in North Georgia, too.

Linda Gail Housch, a young graduate of Spelman College, researched black history in Northeast Georgia in 1969 for the *Daily Times* and painted the following picture:

> It is very interesting to note at this point that although the white small farmer in the Northeast Piedmont region of Georgia (including Hall County) did not especially love the black man, he did not love the white planter, either. . . .
>
> In the book, *Make Free*, William Breyfogle cites that the white man in the Northeast Piedmont often considered himself the victim of having to compete with slave labor and a slave economy. He felt a very strong hostility against the rich, slave-holding planter. Many times this North Georgia small farmer would give aid to runaway slaves. . . . This means that white North Georgia "hill people" actually participated in the Underground Railroad.[1]

There is some evidence that the "hill people" did exactly that, but there is also ample evidence that these same people feared that if the plantation economy were brought down, it would take the entire South down, small farmers included.

The slavery and states' rights issues were a part of Georgia politics for 20 years prior to the Civil War, but it should be noted that when South Carolina proposed secession in 1850, it was Georgia that shut them down.

Historian Kenneth Coleman points out that as the state went into the pre-Civil War elections "Breckinridge men tended to favor secession, with the significant exception of the north Georgia farmers, who voted for Breckinridge but two months later refused to follow Brown and Cobb into the secession camp. Non-slaveholding counties tended to favor cooperation and slaveholding counties, especially traditional Democratic ones, tended to favor secession. The towns and cities tended to be much more attracted to secession than the countryside."[2]

When the convention assembled in Milledgeville in 1861 to consider secession, a resolution calling for secession passed on the third day by a narrow margin, 166 to 130. The next day, the conservatives got a resolution on the floor aimed at reversing the secession vote, but it was defeated 164 to 133. Kenneth Coleman states, "The conservatives were clearly beaten, and a last vote on the formal secession ordinance passed 208 to 89."[3]

Even though there had been serious opposition in Northeast Georgia to secession, once Georgia made the decision to become a part of the Confederacy a sizeable number of North Georgians volunteered to fight with the gray army of the South. The Georgia Department of Archives and History, as well as Lillian Henderson's Roster of Confederate Soldiers of Georgia 1861–1865, lists 14

A statue of Confederate Colonel C.C. Sanders was placed adjacent to the Gainesville Post Office, and was said to be the only Confederate monument on federally-owned land. It was destroyed by the tornado of 1936.

companies of men who were organized in Hall County alone, drawing volunteers from Hall and surrounding counties. In both Confederate and Union ranks, the men from mountainous North Georgia gained a reputation as tough, disciplined soldiers and exceptional marksmen.

A historic marker at Redwine Church, just south of Gainesville, gives a prime example of the kind of service they rendered:

> Co. D, 27th Ga. Inf., Colquitt's Brig. CSA, organized here in early 1861, fought at Williamsburg, Seven Pines, Seven Days Battles. At South Mtn., Md., Sept 14, 1862, against great odds, men of this Co. withstood four attacks by a heavy force of Federals, in a great display of bravery. Later, they fought at Antietam, Fredericksburg, Chancellorsville, Charleston. At Olustee, Fla., Feb. 20, 1864, they helped drive the Federals from Fla. Until Lee's arrival, they helped hold in check Grant's army at Petersburg, Va. They fought last at Bentonville, N.C., and surrendered at Durham, N.C. Apr. 26, 1865.

It may have been a "Lost Cause," but a lot of everyday, non-slaveholding Southerners gave it their all.

When the Confederate troops returned home, mostly by walking from wherever they were the day the war ended, the Southern economy was in a shambles. The Gainesville *Daily Times*, in its edition commemorating the 150th anniversary of Hall County, said this: "Southern wealth had been chiefly in slaves

and land. Many invested in Confederate bonds. . . . So the capital base of the region, including this area, was greatly depressed. Land values collapsed . . ."

However, the farmers of the mountains had an advantage over those in plantation country. Mountain farmers could exist on their own land, and take chickens and eggs and other items to town to barter with merchants on Saturdays. When they needed cash, they took gensing and deer hides and small animal pelts. Mountain land was not as desirable as that in flatter country, for mountain farms were not as easy to reach. The difficulties of Reconstruction on the white population were lessened in Northeast Georgia, for there were fewer blacks to vote, so "carpetbaggers" tended to work elsewhere, meaning the local economy and government was left in the hands of the local mountain people. There was also a belief among outsiders that mountain men were better shots and quicker to use their guns to defend their land, so they tended to leave them alone.

One of the Confederacy's leading generals settled in Northeast Georgia following the Civil War and became one of its most controversial citizens. General James Longstreet was described by William Garrett Piston as "an energetic corps

Survivors of the hard-fighting Company D, 27th Regiment, Georgia Volunteer Infantry of the Confederate Infantry gather at a commemorative ceremony at Redwine Church in Hall County in 1921.

This is a portrait of Confederate General James Longstreet. General Robert E. Lee referred to Longstreet as his "old war horse."

commander with an unsurpassed ability to direct troops in combat."[4] Longstreet fought from First Manassas through Appomattox. He was a major factor in the battles at First and Second Manassas, Seven Pines, Seven Days, Antietam, Fredericksburg, Gettysburg, the Wilderness, Petersburg, and he "scored a decisive victory at Chickamauga."

General Robert E. Lee spoke of him fondly as his "old war horse," and Longstreet commanded the First Corps of Lee's army from its creation in 1862 to the surrender in 1865. At the end of the War between the States, Longstreet stood right alongside Lee and Stonewall Jackson as a Confederate hero. But that image soon faded. According to historian William Piston, "When he joined the Republican party during Reconstruction, Longstreet forfeited his wartime reputation. . . . As a product of the Georgia backwoods, Longstreet failed to meet the popular cavalier image embodied by Lee, Stuart and other Confederate heroes."[5]

Longstreet came to Gainesville, Georgia, in 1875, thinking it would likely become the railroad center of the Southeast. He bought from one Alvah Smith, for $6,000, the Piedmont Hotel and existed on income from that venture and various appointed federal jobs. He was openly Republican in a solidly Democratic South, and in the face of Southern politics, he steadily lost both political and personal support. William Piston commented that "His new role as the villain of the Lost Cause was solidified by his own [embittered] postwar writings."[6] General Longstreet is buried at Alta Vista Cemetery, in Gainesville, under a tombstone that carries both the United States flag and the battle flag of the Confederacy.

The economic devastation of the South, including Northeast Georgia, from the War between the States can probably be summed up with one statistic. In 1860, six Southern states, Georgia among them, were among the ten leading states in per capita wealth in the entire United States, and thus business investment capital was readily available. In 1880, no state in the South was in the top 20 in per capita wealth, and investment capital would be in short supply for the next 100 years.

Perhaps just as damaging to the economic redevelopment of the South was one of the penalties levied by the Union against the South following the Civil War. Using the logic that the Union wanted to be certain the rebellious South would never again arm itself, and especially manufacture the goods necessary for war, railroad rates were controlled and a two-tier system was thrust upon the South. Tier one was for raw materials (raw cotton, minerals, iron ore, leather, etc.); these could be shipped from the South to the North at "standard" rates. Tier two was for manufactured goods. Manufactured goods shipped from the South to the North would be charged one-and-one-half times "standard" rates, while manufactured goods shipped South from the North would be charged at "standard" rates. The example is over-simplified, but that was the way it basically worked.

With the exception of cotton mills, this two-tier rate system very effectively stopped the development of heavy industry in the South, and was a severe deterrent to potential industrial development in mineral-rich North Georgia with its known deposits of copper and iron.

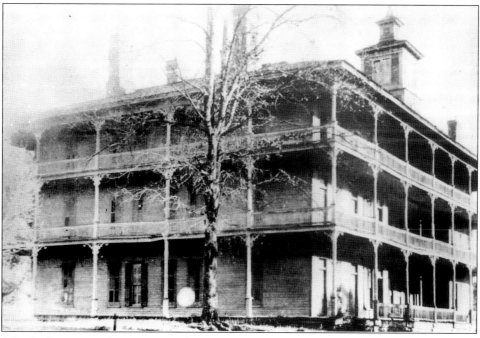

The Piedmont Hotel was operated by General Longstreet and is seen here c. 1890.

A U.S. flag flies over General Longstreet's grave in Alta Vista Cemetery in Gainesville. The tombstone depicts both the U.S. flag and the Confederate battle flag.

Longstreet's country home was destroyed by fire.

The two-tier railroad rates, as mandated by federal law, remained in effect until after World War II, when in 1946, Ellis Arnall, then the young governor of Georgia, challenged the system in the United States Supreme Court, and won. Even so, this author in 1955, serving as executive secretary of the Georgia Poultry Federation, appeared before a Congressional Committee seeking "milling in transit" rates for Georgia's emerging poultry industry, an advantage provided feed mills in the North and Midwest, but not in the South.

It was this lack of investment capital, combined with penalties against manufacturing, that led Henry Grady, editor of the *Atlanta Constitution* and visionary of the New South, to report on a funeral in a mountainous, North Georgia county. He told of the fine pine casket, the nails, the new overalls with shiny buttons, the fine leather shoes—all manufactured in the North. And, he noted, the only things manufactured in the South were the body and the hole in the ground. Northeast Georgia's mountain area had not been wealthy prior to the War between the States. After the war, it was destitute.

7. BEGINNING THE LONG ROAD BACK

Georgia's mountain people had some advantages as the South started its long road back from the economic disaster of the Civil War. At least General Sherman had not destroyed their farms or burned their homes as he had done in much of Georgia. Sherman's army had marched through Georgia where the railroads were, and where the traveling was fast and easy. He went south on the west side of the state, entering at Chattanooga and driving through Atlanta before turning southeast to Savannah. He came back north through plantation country on the east side of the state. Through the years, a lot of people steered clear of the mountains of Northeast Georgia, and the Union's General William Tecumseh Sherman was one of them.

Farmers returning to Northeast Georgia following the war found their farms intact, and began to plant their crops, tend their livestock, and rebuild their lives. Because of the nature of the land, its red clay, and its minerals, as well as its abundant forests, there were other opportunities for extra income. There was still some gold to be found in certain areas, although its veins were no longer rich enough to warrant going into gold mining full time. But for many, it did add some spending money. There is a story about one young farmer who tended his land and panned gold in nearby streams in his spare time, and after two years, he had enough gold to buy a new Walker buggy in Gainesville.

Several brick yards were opened, proving that Georgia's red clay was good for something. There was constant exploration for copper and iron ore, but this never proved to be a viable business. Farm folk got a good bit of extra spending money collecting and selling gensing, or "Sang," as many called it. As always, there were deer hides and small animal pelts. In many ways, this was the frontier survival mode, but the foothills and mountains of Georgia were closer to their frontier years, and better fitted for survival, than were the more developed plantations and cities of the South. There were some small industries, too, that made their

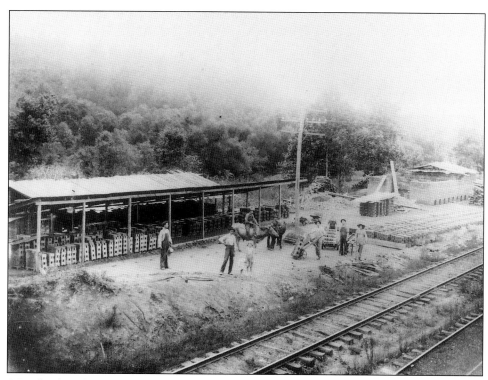

Most brickyards were located near railroad tracks. Employees worked ten-hour days, six days a week, for $1 a day.

contribution to the recovery: gristmills located at waterfalls, maybe a little moonshining, and pottery making.

Early America had many small "cottage industries," most home-based in farming areas, that were a vital part of the frontier economy, and Northeast Georgia was no exception. There were the rustic furniture makers, like those around Clayton and Tiger, who made twig chairs from mountain laurel and rhododendron. There were the basket makers, and those who split shingles. There were the small sawmillers and the blacksmiths who, when not shoeing horses or refitting iron tires for wagons, knocked out fireplace pokers or latches for gates. But no group of craftsmen was more at home along the lower edges of the Blue Ridge Mountains than Northeast Georgia's pottery makers.

Pottery making, quite naturally, tended to locate where there was both an adequate supply of stoneware clay and a reasonable market. Although there were eight recognized pottery-making communities in Georgia's Piedmont region, two of the greatest concentrations were to be found in the White County area. One centered around the Mossy Creek community, and the other not far away at the corner of Hall, Banks, and Jackson Counties, with Gillsville as its focal point.

Hand-thrown pottery is now generally looked upon as art, but these potters did not consider themselves to be artists—far from it. They were in the business

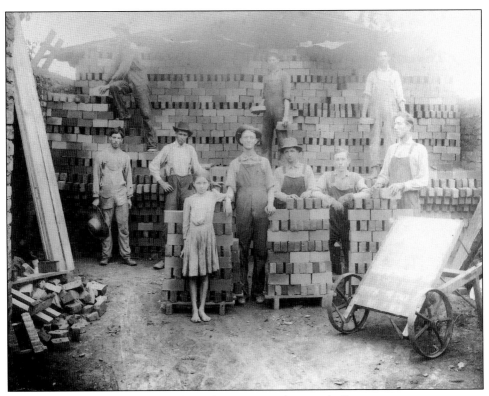

Georgia's red clay made good bricks as this c. 1910 photograph illustrates.

of furnishing durable everyday vessels for farm families: butter churns, pickling crocks, syrup jugs, and, yes, gallon containers for corn whiskey. Potters liked to make the large items, for pottery was priced "by the gallon"—that is, how many gallons a vessel could hold; all except the jugs for corn whiskey, which were supposed to hold exactly 1 gallon.

John A. Burrison, in his great study of folk pottery in Georgia, *Brothers in Clay*, says potters were active in White County as early as 1820 and in Gillsville a couple of decades later. The industry "topped out" about 1880 and began a gradual decline as manufactured glass containers entered the market.

The pottery business of North Georgia, more than other craftsmen-driven occupations, tended to center around certain families . . . and that is still true. Some old-timers say there are two reasons for this: first, pottery-making is hard work; and second, there were "trade secrets" involved. A successful potter had to know how to select and work his mud; he had to be not only good, but also fast on the wheel; he had to know his glaze; and he had to know how to fire the pottery in a kiln.

Among the Mossy Creek potters, Burrison found a history of families with names like Anderson, Brown, Brownlow, Cantrell, Chandler, Craven, Davidson, Dorsey, Eaton, Hall, Hewell, Hogan, Humphries, Jarrard, Jenkins, Lowry,

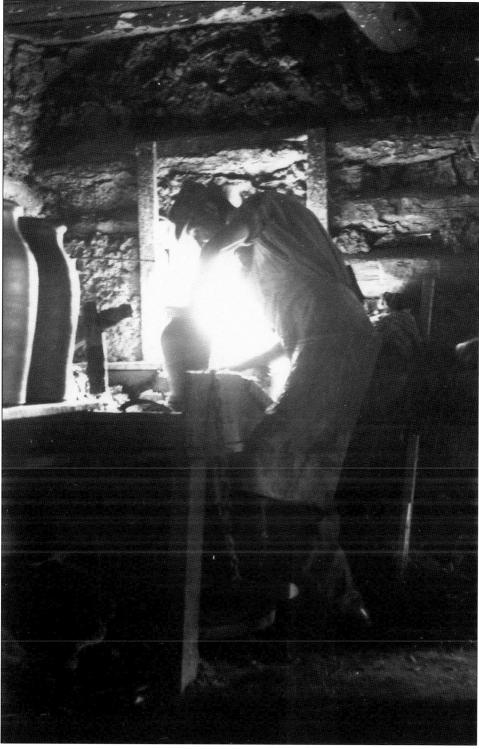

A Georgia potter is seen here in 1935 at work making art ware. Note the kick wheel.

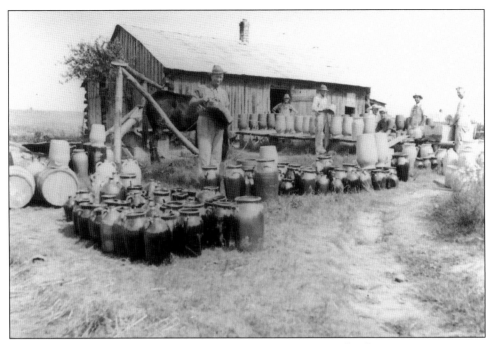

This 1935 picture shows the Roy Holcomb Pottery Works in Gillsville.

Meaders, Pitchford, Sears, and Warwick; and around Gillsville, Addington, Brown, Chandler, Colbert, Craven, DeLay, Dodd, Ferguson, Hall, Hewell, Holcomb, Perdue, and Wilson. Others were involved in selling the wares, but these listed names were the families identified as pottery turners.

Actually, pottery was not new to the mountains and foothills of Northeast Georgia when the white man arrived. Chards of Indian pottery were found in the Chattahoochee River, near Sautee, as late as 1999. But for almost a century, it was one of the recognized local industries that provided a livelihood for families in the low mountains, and on a smaller scale, it still exists in the year 2001.

No matter how hard working, how industrious the residents of Northeast Georgia might have been, in the big picture, they were not going to be a part of the fast-growing American economy until they got better transportation, and in this, they got a break. In 1871, a railroad began operation from Charlotte to Atlanta.

Rebuilding, and then expanding, the railroads was one of the first business priorities in the reconstruction of the South following the Civil War. Northern capital was available. Cotton was in short supply, both for export and for the newer cotton mills in New England. The primary trunk line serving North Georgia was still the route from Augusta to Atlanta, now linked to the Georgia state line at Chattanooga.

A company had been formed in 1856 to build a railroad through Toccoa, Georgia, linking Atlanta and Charlotte. Held up first by a depression and then

the Civil War, this project was renewed after the war. Known as the "Air Line" Railroad (its real name: the Atlanta and Charlotte Airline Railroad), it traveled down the "Eastern Divide," skirted close to the mountains, and was hailed as the shortest route from the "Deep South to the North." It ran through Toccoa, Cornelia, and Gainesville.

The arrival of the railroad had an immediate and dramatic impact on Gainesville as a trading center. Although a goodly amount of cotton was grown in Northeast Georgia, it was generally carted by wagon and sold in Athens and other railroad towns to the east. In 1870, it was said, only two bales of cotton were sold in Gainesville by local farmers. In 1872, after the railroad arrived, 1,500 bales were marketed there. Cotton merchants, like L.R. Sams, moved their base of operations from places like Covington and other small towns to Gainesville.

The location of this railroad line renewed interest in an east-west line through Gainesville, despite the fact that Atlanta was already developing as a transportation center. After all, a northern route through Gainesville would save 80 miles on the trip from Augusta to Chattanooga.

Local tradition says one of the reasons Confederate General James Longstreet located in Gainesville after the Civil War was his belief that it (and not Atlanta) would eventually become the transportation hub of the South. The fact that he was highly interested in railroad ventures, and eventually served as United States

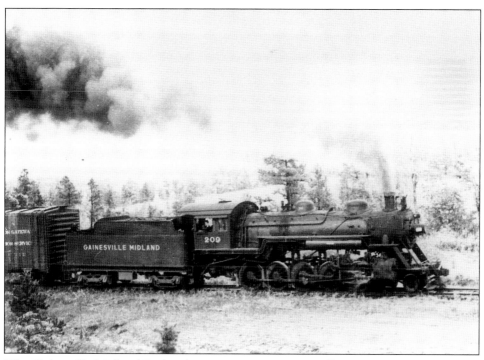

The Gainesville Midland Railroad's Engine 209 was originally intended for delivery to the czar of Russia c. 1918.

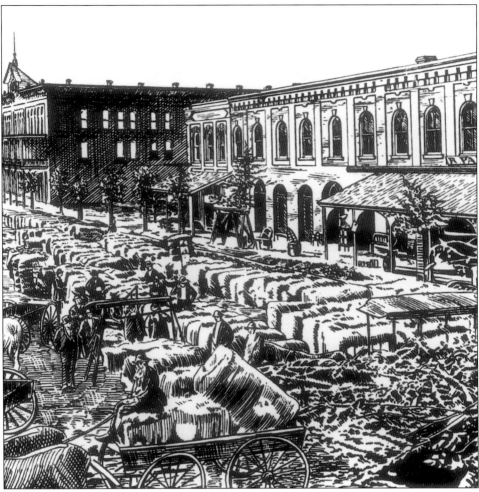

The Gainesville square is seen here in a depiction of the town during cotton season, c. 1890.

Railway commissioner under President Ulysses S. Grant, adds to the credibility of this story.

Gainesville did not become the railroad center of the South; Atlanta did. But Gainesville did become the railroad center, and thus the trading center, of mountainous Northeast Georgia. Development came rapidly in the 1870s. In 1871, the Atlanta and Charlotte Airline Railroad began operation in Gainesville. In 1872, the Gainesville, Jefferson & Southern Railroad was chartered, a 52-mile line that ran to Athens, and thus linked Gainesville with Augusta and the ports of the East Coast. In 1876, the Northeastern Railroad of Georgia opened, connecting Athens and Lula (just north of Gainesville), where it connected with the Air Line railroad.

The nationwide railroad boom of the late 1800s created a speculative "gold rush" attitude among Americans. A lot of money was made, and probably a lot

more lost, investing in railroads. Among the losers in Georgia were a lot of towns and counties that did not want to be left out, as Gainesville had been when that first railroad went to Atlanta in 1837 rather than crossing the Chattahoochee at Wynn's Ferry. A lot of local governments, with their citizens' blessing, used tax money to lure railroads to their location, and a lot of those enterprises failed to complete their rail lines, or went broke soon afterward. Eventually, the state legislature passed a law making it illegal for the state, or for local governments, to speculate on railroads or other private ventures. Thus, Gainesville reported in 1888 that, although it had railroads, it did not owe any public money for railroad ventures, and it went on to say, "No county or municipality can incur a debt or appropriate a dollar for aid to any railroad or enterprise . . . the same restriction is upon the State government."

By 1900, the great era of North Georgia railroad speculation was ending, but two colorful mountain railroads were yet to come. Both hauled lumber as their volume freight, but each also played a major role in opening the mountains to a lively summer resort development.

The Tallulah Falls Railroad was completed in 1907, traversing rugged mountain terrain from Cornelia, Georgia, to Franklin, North Carolina, a distance of 58 miles. Although it hauled a tremendous amount of lumber, it was probably best known among well-to-do Atlantans as the railroad to Lakemont, the passageway to Lakes Rabun, Burton, and Seed. The Lakemont area became the summer

This is the railroad station at Lula, Georgia.

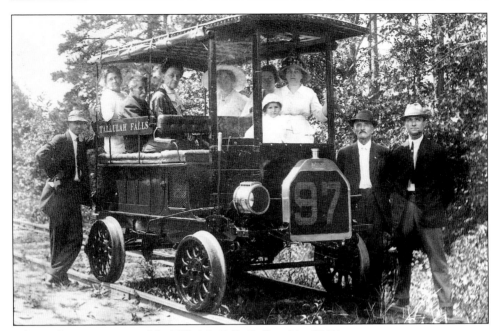

This is the executive car of the Tallulah Falls Railroad in 1917.

playground for several generations of wealthy Atlantans, and the "TF" was their primary means of transportation to and from the city.

The "TF," fondly dubbed the "Total Failure Railroad" by its loyal summer customers, had spectacular wooden trestles across some of the deepest gorges in the mountains, but for half a century, it delivered goods to people in the Georgia and North Carolina mountains and it delivered a lot of lumber to cities of the South. The Tallulah Falls Railroad finally failed in 1961, its economic function long since replaced by cars and trucks on paved (although narrow and dangerous) mountain roads.

The Gainesville and Northwestern Railroad (G & NW), completed in 1912, traversed only 37 miles from Gainesville to Helen, Georgia, and was built primarily to serve the massive Byrd-Matthews (later Morse Brothers) Lumber Mill. In its heyday, this mill produced 125,000 board feet of lumber per day, and the railroad connection in Gainesville allowed the company to ship lumber all over the eastern United States as well as to Atlantic ports for export. In addition to the main line, a branch extended from Clermont to the pyrites mine in Lumpkin County.

The G & NW ran from Gainesville to Brookton, Clermont, Cleveland, Yonah, Nacoochee, Helen, and Robertstown, opening up north Hall and White Counties to commerce and tourism. Hotels, eating establishments, and summer homes were established along its route. In its early years, the G & NW ran excursion trains to Mossy Creek Campground and Escowee Falls, between Helen and Robertstown, providing all-day outings for courting couples and city families.

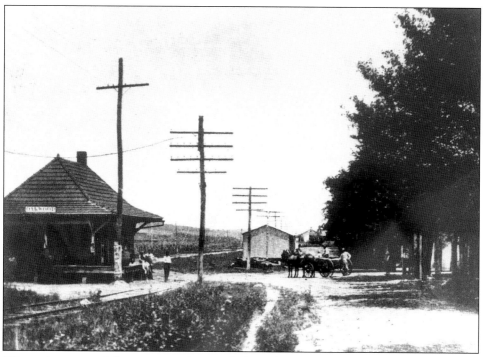

The main street and depot are seen here at Oakwood c. 1900.

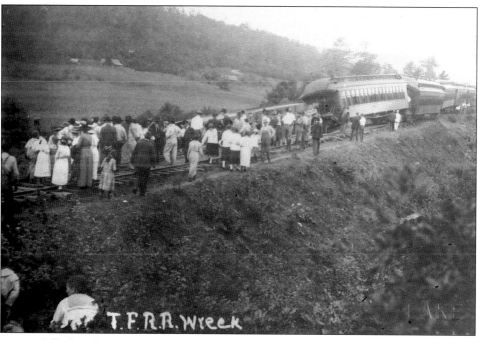

It was difficult to keep trains on the tracks in the mountains. This wreck of a train from the Tallulah Falls Railroad occurred south of Tiger.

Mountain railroads required stacked, wooden trestles and deep earth cuts.

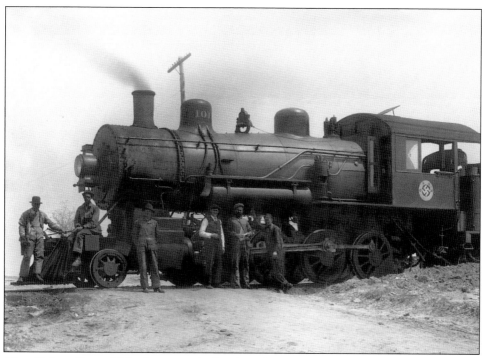

The Gainesville and Northwestern Railroad used an ancient Indian symbol as its logo. A similar symbol, called a Swastika, was later used by Adolph Hitler in Germany. There was, of course, no relationship.

In addition, the Morse Brothers sawmill built a complex network of narrow-gauge logging railroads, in all 150 miles of rail lines reaching deep into four counties, to bring a constant supply of logs from the mountain forests to its massive mill. The G & NW, for all practical purposes, ceased to operate when Morse Brothers closed down in 1928, but a contraption nicknamed "the Yellow Hammer" (literally a bus on railroad wheels) continued to carry passengers and mail as late as the mid-1930s.

The great hope that Gainesville would become the railroad center of the South never materialized. It was perfectly located, on a straight line from Augusta to Chattanooga—but then there were those mountains.

8. The Great Health Resort of the South

By the mid-1800s, the families of wealthy people along the U.S. East Coast were spending the summer in the mountains of Georgia and North Carolina, similar to the pattern in which the affluent society of New York spent the summer in New England and later in the Adirondacks.

First, the climate was cooler, so they escaped the oppressive heat and humidity of Southern coastal cities and inland plantations. Second, the mountain air was known to be healthier. Those who stayed along the coast ran a much higher risk of contracting malaria, or as it was commonly called, "the fever," or to be even more descriptive, "the bilious fever."

In 1829, one Adiel Sherwood authored a small travel book, published in Philadelphia, called the *Gazetteer of the State of Georgia*. "In North Georgia," he wrote, "there is no purer water, nor any healthier climate on the globe." The author spoke highly of Clarkesville, Clayton, and Gainesville, and then added, "In the months of August, Sept. and Oct., the bilious fever obtains in the lower and middle sections of the state . . ." The implication, of course, was that one was immune to the fever while in the mountains—and to some degree this was true.

These well-to-do summer residents were coming to Clarkesville as early as the 1830s, while the new land owners were still trying to remove the Indians from the area. Visitors from Savannah and Charleston came via Augusta to Athens, then took the four-horse stagecoach to Clarkesville. The Episcopal Convention was held in Clarkesville in 1840, drawing in many people who had not seen Northeast Georgia before and "the following summer many who had not known of Clarkesville came, and the town was filled to overflowing with visitors."[1] A host of hotels was built through the years: the Spencer House, the Free Hotel, Alleghany Hotel, Fuller House, Grove House, Phoenix, the Eureka, which catered to Florida guests, and the Village Hotel, which was built in 1833 and later became the Habersham House and then Mountain View. Most were fine wooden

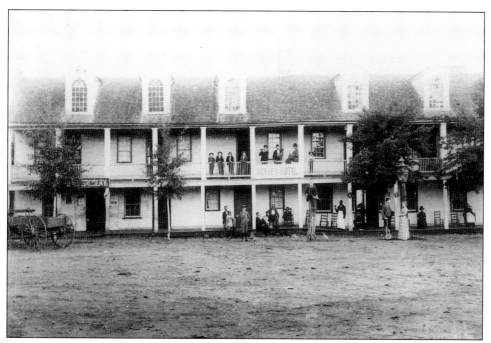

This is the Eagle Tavern in Dahlonega.

structures with wide, breeze-washed porches, and almost all had a reputation for great food.

Other spots, unique but much more difficult and dangerous to reach, became popular—places like Tallulah Gorge. One of the most spectacular gorges in the eastern United States, the chasm is 2 miles long and nearly 1,000 feet deep. On the very rim of this gorge a hotel called the Cliff House was constructed, and later, after the railroad was built, Tallulah Lodge. Then, there were the King House, Willard House, Taylor House, Maplewood Inn, The Pines, Oak Haven, and Glenn Brook. The gorge became a thriving summer playground.

Most summer visitors stayed in the hotels or rented houses prior to the 1860s, but many built elegant country homes and became part-time residents. A summer culture developed, which was great fun for the visitors and an economic boom for the mountain folks. Not only were most families wealthy who "summered" in Habersham and adjoining counties, but many individuals also were politically powerful. John McPherson Berrien, the U.S. attorney general under President Andrew Jackson and a two-term U.S. senator, was one critical contact in Washington during the Indian land negotiations. It is easy to speculate that the mountains of Northeast Georgia were rapidly developing to be a summer resort.

In *Georgia Life Magazine*, an article contained the following:

> Until the late 1850s the plantation vacationers continued to build, creating a world sought to emulate the one found in the writings of

71

White Sulphur Springs had 40 of these cottages, where wealthy families spent the summer.

Sir Walter Scott—full of gallant gentlemen and their ladies. . . . Parties would last for several days, with the visitors arriving in the afternoon or early evening for dinner and dancing. Next morning there would be a hunt breakfast and the men would go out on a shooting party that would occupy them until evening, when there might be a party to celebrate the results. These times were short-lived, and were gone forever before some of the houses were a decade old.[2]

There were many casualties of the Civil War. The brief era of summer mountain homes built in Northeast Georgia by plantation owners, ship captains, and coastal merchants was one of them. The summer resort industry was economically dead for the decade after the Civil War. Then, as the economy improved along the coast, as investment capital trickled in from the North, and especially as the railroads probed farther into the mountains of North Georgia, a new and different mountain resort business began to develop.

Visitors to the mountains still came to escape the hot, humid weather along the coast. They came to the springs for health reasons. But now, they tended to come for shorter "vacation" periods instead of spending the entire summer. Instead of recreation and parties at wealthy friends' homes, they sought recreation at resorts. It seems fair to report that the "big money" went into the higher mountains, to Asheville or Highlands, but Northeast Georgia was always a major player as a mountain playground.

The railroads made travel easier, and because Gainesville developed as the railroad center of mountainous Northeast Georgia, it was also effectively promoted as the focal point for summer visitors. A "Guide to Health and Pleasure Resorts on the Piedmont Air-Line Route—More Especially Summer Resorts of North-East Georgia" was published in 1878 and described Gainesville as "the commercial centre of this section of Georgia." The 36-page brochure went on to say that Gainesville "is destined to become the leading summer resort of the South, as it is in the very center of all the great healing Springs, and Gold Region, and is the most convenient point from which to reach them."

So, while many well-known resort facilities developed in North Georgia that could furnish "cool, bracing air" and freedom from malaria, Gainesville had two other attractions which proved to be compelling. First, it developed to a size—a critical mass if you will—which offered dance bands, an active opera hall, an ice cream parlor, a lakeside recreation center, educational lectures, and a wide variety of recreational activities for all ages and family members. It was not a rambunctious town, but it was a fun place to visit.

More important were its springs. "The medicinal waters of the vicinity of Gainesville were long used and prized by the Indians, and since the settlement of

White Sulphur Springs was advertised as early as 1849 as a premier mountain resort. In this view, a few guests are seen enjoying the resort's gazebo.

the country by the whites, they have been resorted to annually by invalids from all portions of the South," said one promotional brochure. A family did not have to spend the entire summer to get the benefits of the mountains; two weeks in the cool, fresh air combined with the mineral springs did the job.

And what a job these springs did. Promotional brochures gave the picture. The springs in Gainesville's City Park were "of great virtue for dyspepsia, sick headache and general debility." At Gower Springs, the waters were "chalybeate in their character. The iron being held in solution by carbonic acid is more readily assimilated than in any other combination. In general debility, all kidney troubles, indigestion, hemorrhoids, and in all cases requiring a tonic they are very valuable." At New Holland springs, "the water is efficacious for indigestion, general debility, and especially recommended for teething infants and children."

As Reconstruction took hold and the Southern economy came out of the doldrums, Gainesville literally exploded as a family "health resort" boom town. Genteel visitors came to Clarkesville and the Sautee-Nacoochee Valley. Even the rough-and-tumble gold town of Dahlonega began to draw summer visitors.

In 1874, Gainesville's first horse-drawn "street railroad" was built, linking many homes that hosted summer visitors with the springs and the rest of the city. That same year, the Piedmont Hotel was built, a "cool and comfortable" building later owned and run by Confederate General James Longstreet, fondly remembered at the end of the Civil War as "Lee's war horse." Then came the boom in Gainesville. Gower Springs was built in 1877; the Arlington Hotel, in 1882; and the Hudson House, in 1887. A number of classic Victorian homes were built and partially paid for through rent from selected summer visitors.

The city of Gainesville probably reached its peak as a resort town in the 1890 to 1910 period, and promotional literature indicates there were at least four hotels that could accommodate more than 100 guests each, and one brochure lists eight

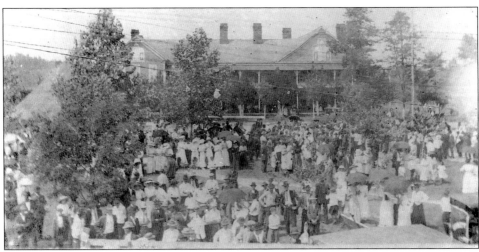

This photograph captures a July 4th celebration at the Mountain View Hotel in Clarkesville.

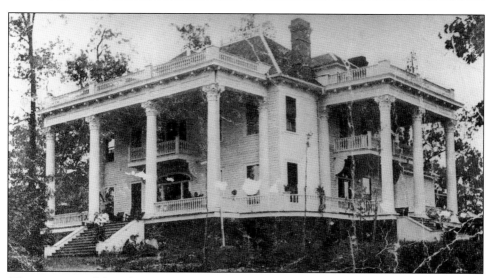

This is a view of the Charm House in Clarkesville.

other hotels capable of handling 20 to 40 guests, as well as many homes with rooms for smaller numbers.

The Arlington Hotel, on the main square, was "the great center of the social amusements during the season, having a delightful ball room and a splendid band at the service of the young folks every evening." On another corner of the main square was the Opera House, and special activities were common at City Park. There was an art gallery run by Early Rogers. One could go swimming at the river, or participate in lawn bowling or billiards. For those who desired, afternoon relaxation or evening libation was available at saloons. The 1882 Gainesville City Directory said, "The Alhambra takes the lead as being the only place in the city where a good drink may be obtained." And the classy Piedmont Saloon was an orderly and well-kept place with the purest of liquors and the best brands of cigars. All the hotels, recreational activities, and springs were tied together with the unique streetcar line, converted from horse-drawn to electric power, which ran from the railroad station through the main square to the Chattahoochee River.

In the South at the turn of the century, from June through October, the place to be was Gainesville—promoted by most as the "Queen City of the Mountains," and by others as the "Gateway to the Mountains." Gainesville became a honeymooner's Mecca, and many families scheduled their vacations to be "in Gainesville" at the same time as friends and relatives from other parts of the country. Regular returnees from faraway places talked about their "summer family," meaning the people they had come to know through their regular summer visits to Gainesville. It was a mountain resort town with a following.

Although Gainesville tended to be the business center of this new economic engine, it certainly did not have a lock on the health resort business, let alone the mountain resort business. In fact, the two most widely known health resort

Both Woodrow Wilson, President of the United States, and Alexander Stephens, vice-president of the Confederacy, enjoyed the facilities of the famous resort White Sulphur Springs.

"watering holes" were not in Gainesville at all. White Sulphur Springs, 6 miles north of Gainesville, was an independent resort unto itself, and Porter Springs was located 28 miles from Gainesville in Lumpkin County. Porter Springs, which could accommodate about 150 guests, had the advantage of being 3,000 feet above sea level. Although it was well appointed and featured superb food, it was not a posh resort.

As the nineteenth century came to an end and the calendar turned to the twentieth, White Sulphur Springs was one of the finest summer health resorts in America, and considered by many as by far the best in the Deep South. It had been built as a health resort prior to the War between the States, although the exact year is uncertain. In 1846, however, one L.A. McAfee ran an advertisement in the *Augusta Sentinel-Chronicle* which said, "not being able to improve the springs in a deserving manner, desires to sell all or part of the property to a man or company of capital." Even so, it was a popular resort for wealthy people both prior to and after the war. A report on the springs, published by the 1913 Geological Survey of Georgia, noted, "Prior to the Civil War, the wealth and fashion of the state annually gathered at this resort."

It remained popular but, though well maintained, its buildings and grounds did not compare favorably with some of the newer resorts in other parts of the South, and particularly those in Florida. It kept its active following greatly because of the

reputation of its waters. Nancy Bailey, in her thorough study of the old resort, notes that in 1905, Oconee White Sulphur was bought by Colonel J.W. Oglesby, a railroad owner, cotton grower, and lumber magnate who reputedly "poured a million dollars into the area and had a flourishing business."

White Sulphur was really a resort community. There was the large wooden hotel with wide porches, rooms with baths for well over 100 guests, and as many as 40 guest cottages on the grounds which could accommodate from five to ten people each. The dining room could seat more than 100, and it featured silver water pitchers and fresh flowers for each table. There were landscaped walkways, two large gazebos, gathering places, and benches. The springs were at the foot of a hill and were "easily approached by winding walks and drives." The baths were reported to be fashioned after a European spa design, and there was a pavilion over the springs. The springs were noted for "marvelous cures wrought by the water in cases of rheumatism, blood poisoning, dyspepsia and other complaints." The bathhouses included both shower and plunge baths, and a large swimming pool. There was a ten-pin alley for bowling, and billiard and pool tables. One promotional brochure captures the romantic scenery and events with the following comment: "A large ballroom in the hotel is nightly the scene of a german or waltz. A most excellent band enlivens the afternoon with choice selections and affords music for the dance in the evening."

White Sulphur had its own stop on the Air Line Railroad, 2 miles away. The hotel offered Western Union service for visiting businessmen, and had a resident physician. It was elegant, and expensive. White Sulphur continued its popularity long after other resort attractions had begun to decline, and the famed location is said to have reached its zenith in the 1920s. But the good colonel, it seems, was

A number of small hotels were located along the railroads in Northeast Georgia. Seen here c. 1920, this one was situated in Clermont, a railroad village formerly known as Dip.

77

a major investor in the stock market, and the Crash of 1929 took him down, and with him his fabled summer resort. Closed from 1929, the deteriorating hotel caught fire and burned in 1933.

While Gainesville developed as the dominant health resort in Northeast Georgia, many visitors preferred to go to higher mountain locations. Clarkesville and Demorest were still desired destinations. White County had its Henderson Hotel, in Cleveland; Mitchell Mountain Ranch, in Helen; and the Alley House, magnificently located overlooking the convergence of the Nacoochee and Sautee Valleys. In Dahlonega, the Mountain Lodge, originally for employees of the Consolidated Gold Mining Company, was opened to the public after the demise of the company in 1906. It had 45 rooms and 2 dining rooms. In summertime, all Northeast Georgia, it seemed, was blessed with visitors willing to spend good money for the cool climate, beautiful mountains, and healing waters.

In the early 1900s, another wave of summer home development started in the mountains, and this probably can best be characterized by the events on Lake Rabun and the community called Lakemont. The scenic mountain area around Tallulah Falls and the amazing Tallulah Gorge below the falls have always attracted people. Even prior to 1900, when transportation to the area was treacherous, there were hotels along the perimeter of the gorge and near the falls themselves. But it was in 1915, when the Georgia Railway and Power Company impounded a

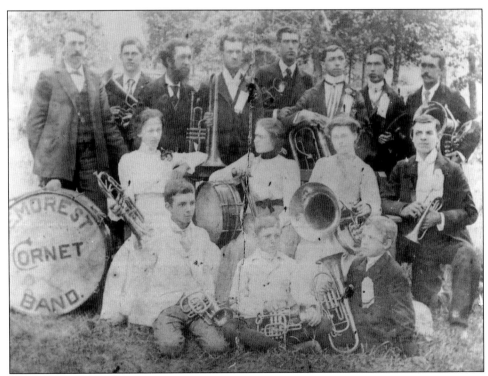

The Demorest Cornet Band poses for this c. 1900 portrait.

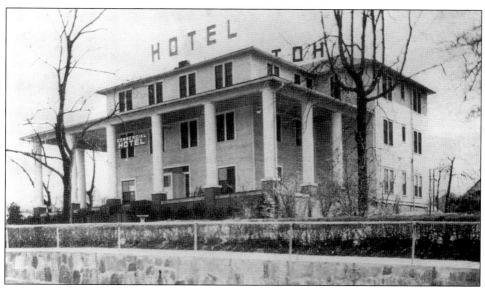

The Commercial Hotel, located in Cornelia, is pictured here c. 1940.

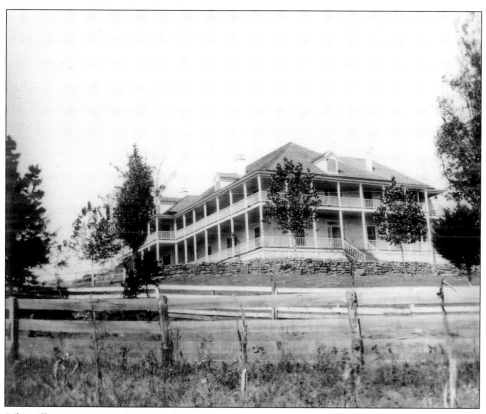

The Alley House was located where the Nacoochee and Sautee Valleys intersect and is seen here c. 1906.

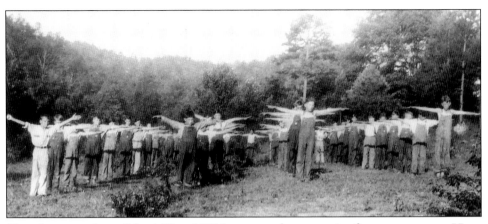

Farm boys, members of the 4-H and FFA, came to the mountains for summer camp. Here, they assemble for calisthenics in 1932.

9-mile, 1,000-acre reservoir to run a hydroelectric plant, that Lake Rabun began to draw its "summer people."

The Tallulah Falls Railroad, which had been completed from Cornelia to Lakemont in 1907, had made travel easier. Atlantans could catch the "Air Line" Railroad (later the Southern) to Cornelia, where they often spent the night at the Commercial Hotel, and then caught the "TF" to Lakemont the next morning. This time it was well-to-do Atlantans, much more than people from the coastal areas, who brought their families to Northeast Georgia to spend the summer. They bought or leased land along the shores of Lake Rabun, with breathtaking views of the mountains, and built their summer homes. Many had smaller cabins adjacent to their main homes for their servants, who spent the summer with them.

As highways improved and America started its love affair with cars, Lakemont became more accessible and literally became the summer outpost for many of Atlanta's pioneer business leaders. Ben Noble Jr., in his 1989 book about Lakemont, noted, "Many of its residents today are old-moneyed families who have known Lakemont since the days when there was no electricity or telephones."[3] The Georgia Power lakes developed a culture all their own—a relaxed mountain lifestyle tied together by mahogany Chris-Craft powerboats and long-standing friendships.

While the adults sought the mountains for relaxation, beautiful scenery, and cool breezes, the kids burned organized energy in a string of classic summer mountain camps. These camps were, literally, scattered all over the mountains of Northeast Georgia.

Lillian Smith, in *Sketches of Rabun County History*, describes it this way:

> the children came to Rabun County to play. They began to come when
> Mr. A.A. Jameson started a camp for boys called Camp Dixie and more

of them came in 1920 when Reverend C.W. Smith opened Laurel Falls Camp for girls, and still more came when Camp Dixie for Girls opened. And suddenly Rabun County was swarming with children. . . .

They were everywhere: singing at full-lung, hiking, camping, picnicking, studying "nature," looking for birds, swimming, galloping down roads on horses just fresh from spring plowing and still dubious about the dynamic little loads on their backs. A farmer would go to his field on an early morning and suddenly be startled by twenty little heads peering up from underneath blankets . . . They were camping out—learning to be pioneers and Indians—cooking their meals over campfires, building fires in the rain, doing all the things they believed their forefathers had done.[4]

There were a number of camps in Rabun County, such as Camp Marist, which later became Camp Rabun, on Lake Rabun; the Athens Y Camp for boys near Tallulah Falls; "Red" Barron's Camp at Mountain City; Chatooga for Girls, also near Tallulah Falls; Camp Cherokee, on Lake Burton; and the Rainey Mountain Boy Scout Camp, east of Clayton. For most of the twentieth century, thousands of youngsters, most of them from Atlanta and environs, have been an integral part of Georgia's mountains, and loved it.

There is a little plaque that has always been a good seller in the tourist shops of North Georgia; it says, "If you don't think you have any friends, just build a place in the mountains." Truly, there is a magnetism that draws people to the mountains of Northeast Georgia—always has been, and probably always will be.

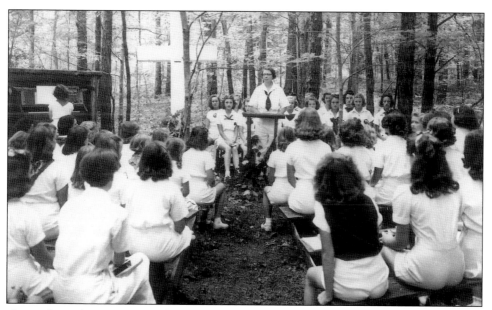

An outdoor religious service is held at Camp Dixie for Girls in 1939.

9. FARM AND FAMILY FINANCES: 1880 TO 1900

History makes it clear that the people of Northeast Georgia were not wealthy. Some longtime families of the region will refer to their ancestors as "dirt-poor." In the New Deal politics of Franklin D. Roosevelt, and even in the welfare programs of President Lyndon B. Johnson, the people of the Southern Appalachians were singled out as poor people who needed government help. LBJ chose Gainesville, Georgia, as the town in which he would launch his federally-financed "War on Poverty," much to the chagrin of many local citizens.

But how poor were they, really? Prior to World War I, those who lived in the country had dirt roads that often were little more than wagon-wide trails. Houses were not painted. Electricity did not reach them until the 1930s when the Rural Electrification Administration was formed. On the surface, at least, they appeared to be poor in comparison with city people.

In the 1950s, a colorful speaker, then a highly successful executive with a major Atlanta corporation, spoke of his "growing up" days this way:

> I grew up in an unpainted old house in the mountains. A swept yard. All of us kids worked long, hard hours. I can remember getting up before dawn and we kids would slide in on the old benches on either side of our eatin' table, and we would close our eyes while our father gave the blessing . . . and gave the blessing . . . and gave the blessing. And as soon as he said "Amen" we lifted our eyes and looked across that scrubbed old table, and there wasn't anything there but . . . [and he would always pause here] fried eggs, and scrambled eggs, country ham and hot sausage, a big bowl of white-eye gravy, a platter piled high with cat-head biscuits, real butter, blackberry jam, blackstrap sorghum. And, of course, two big pitchers of milk.

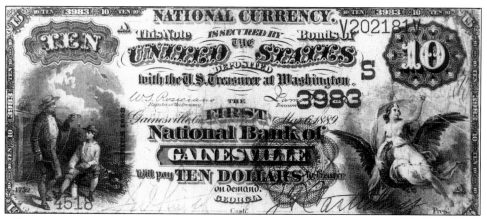

The First National Bank of Gainesville issued this $10 bill in 1889. It was secured by bonds of the United States government.

His story always drew a laugh, but it also told a lot about the so-called poor mountain people.

So, finding good dollars-and-cents information about life in the mountains, and finding ways to compare it to the economy of today, has been difficult. Prior to 1900, how much income did they have? Maybe more important, how much did it cost them to live? This author's research uncovered some settlement receipts from a cotton merchant, and a friend in Atlanta came up with three old ledgers from a hardware store that had operated in nearby Athens, Georgia. Some of the information from them seems worth reporting, for it is very difficult today to understand how a family could live on $300 a year, or even $100 a year, until one realizes that they did not buy much, and what they bought did not cost much when compared with today's prices.

John Ehle, in his book about the Trail of Tears, makes this notation regarding wages and cost of living in early America: "In 1770 Thomas Jefferson's income as a lawyer is figured to have been three-thousand dollars, and his income as a planter using his 5,000 acre estate about two-thousand. These figures help establish a comparison of monetary value between today and 1770: perhaps a ratio of thirty to one." Even though this was 100 years before the following ledger's listed financial figures, it is doubtful prices had changed very much.

On November 21, 1900, J.W. Williams took two bales of cotton to cotton merchants Hodges, Camp, and Arnold, of Winder, Georgia. The first bale weighed 455 pounds, and they paid 10 5/8 cents per pound, for a total of $48.34. The second bale weighed 480 pounds, and they paid 10 3/4 cents per pound for a total of $51.60. Total cash paid to Mr. Williams was $99.94. It is likely that this sum was Mr. Williams's total income from cotton for that season, and also likely that cotton was his major crop.

The ledgers from the hardware store in Athens indicate farmers opened their "line of credit" when they planted their crop, and paid it off when they sold it.

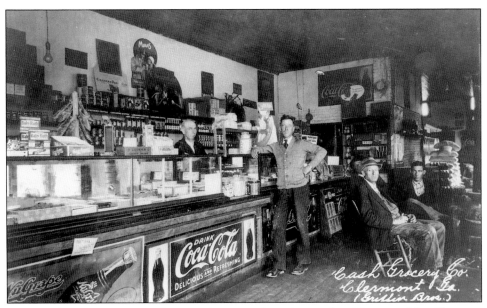

Coca-Cola and NuGrape dominated point-of-purchase advertising at this Clermont store c. 1926.

They charged both their cost of doing business, and their personal needs, during the crop-growing season. The ledgers, dating from 1875 to 1888 to 1892, show that prices did not vary significantly from year to year. Entries in the books were very legible—actually the writing was beautiful:

Shoeing one mule	75¢	Pair of plow handles	45¢
One mattock	75	One harrow	$2.50
Sharpening plows	6¢ each	One bushel of oats	70¢
One bushel corn	$1.00		

For personal expenses, local folks apparently did not buy much at all, although it was traditional in that period for farmers' wives to bring chickens, eggs, and milk, which they traded for other items at the grocery store—so these records may be very incomplete. From the books, the following was listed:

One pair shoes	$1.10	One pair pants	$2.50
One shirt	40¢	One pair socks	10¢
One bottle castor oil	10¢	One spool thread	5¢
One plug tobacco	10¢	One bolt snuff	5¢
One bar soap	5¢	50 pounds flour	$1.63
4 pounds coffee	$1.00	One-half bushel meal	47.5¢
One bushel potatoes	50¢	16 pounds salt	30¢
One-half bushel coal	15¢	One-half peck goobers	12.5¢

A survey made in the city of Gainesville of "the usual prices of staple articles of consumption" showed the following:

Lard, per pound	10¢
Eggs, per dozen	10¢
Chickens, per head	10¢
Cabbage, per pound	1¢ to 3¢
Beef, per pound	6¢ to 10¢
Country syrup, per gallon	40¢
Irish potatoes, per bushel	40¢
Sweet potatoes, per bushel	40¢
Flour, per barrel	$4

It should also be noted that in the 1880s, it cost 2¢ to mail a 1-ounce, first-class letter. And, 1 gallon of high-quality corn whiskey from a reputable supplier was reported to cost from $1 to $1.50 delivered in a locally produced clay jug.

The names of the people listed in the various ledgers may be instructive in identifying from where the original settlers of Northeast Georgia came. They

A young man goes courting in his Walker buggy. The buggy had a black body, plush cushions, and red running gear. It cost about $70 in 1895, and the horse cost extra.

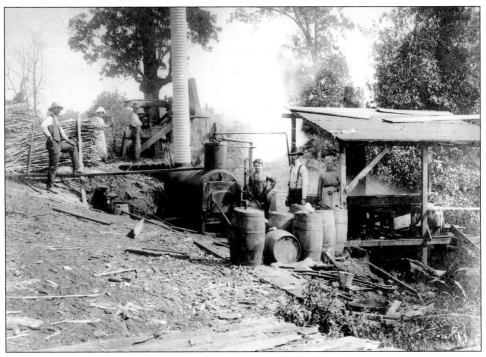

This 1912 sorghum mill was operated by steam power.

would appear to be mostly of English, Scotch, or Scotch-Irish origin. Here is a list of some of the family names recorded in the business ledgers studied: Adams, Anderson, Bagwell, Bell, Blalock, Brown, Camp, Cook, Cronic, Dalton, Davis, Edwards, Flanigan, Gordon, Griffin, Hayes, Hill, Jackson, MacDaniel, Mathis, Parker, Parks, Pierce, Rainey, Reynolds, Rutledge, Sanders, Sims, Smith, Stanley, Staton, Wiley, Williams, Wilson, Wofford, Wood, and Wright.

While agriculture brought in more total income prior to 1900 than everything else put together, what about townsfolk? How did they make a living? Like the farm folk, town dwellers were industrious people who usually had their own gardens. Some had their own cows for milk. Most had sewing machines and bought patterns to make their own clothes, and they expected to repair them. They found ways to make "extra" money. For instance, in the year 2000, property along Gainesville's Green Street has many very large and productive pecan trees, most estimated to be more than 100 years old.

A house with six to eight rooms could be rented (if available) for $10 to $15 per month. Or, if a person chose to build (according to Gainesville's 1888 promotional booklet), "A neat frame house, four rooms 15 x 15, with fire place in each, hall in center, veranda front and rear, plastered and painted, can be completed for $600." The brochure went on to say, "A building and loan association is in successful operation, from which those wishing to build may obtain money for that purpose, to be repaid in installments."

The same source reported that "Skilled labor brings from $1.25 to $2.50 per day; common labor from 50 cents to 75 cents per day." This was before the days of either withholding taxes or two-income families. Jobs were scarce in Georgia's mountainous area before 1900, but business was flourishing, the population was increasing, and the economy was looking up. Gainesville was pushing for more economic growth, and about 1890, the city printed and circulated a leaflet encouraging workers and businesses to move to this "Queen City of North Georgia." The pamphlet pointed out that people were working in a diversity of businesses: "One Cotton Factory, Two Planing Mills, Door and Sash Factory, one Foundry, one extensive Carriage Factory, Two Tin Factories, One Harness and Saddlery Factory, Three Brick Yards, Four Large Livery Stables . . ." Jobs were also available at "Six Large Hotels, kept in good style" and at "Four mineral Springs. Three of which have Commodious Hotels and Cottages . . ." There was always some debate, both in the business community and among citizens generally, about the value of jobs in the seasonal "summer trade."

The promotional brochure made a bold bid for investors to come to Gainesville and establish a furniture factory, a wagon factory, foundry and machine shops, and another cotton factory. The pamphlet ended as follows: "Our winters are short and Mild, our summers cool, scarcely a day in the year when men cannot work

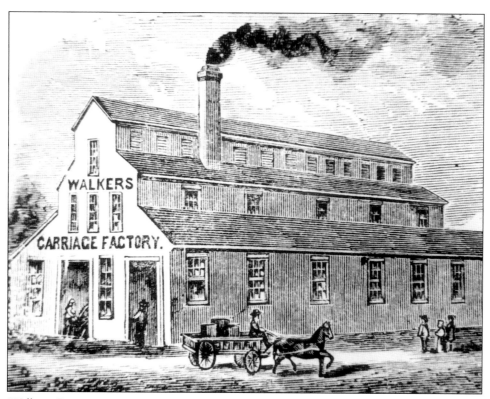

Walkers Carriage Factory was a major industry in Gainesville c. 1890.

This special rig was built for butchering beef in Gwinnett County in 1904.

out doors. Considering our advantages of Climate, Health, Churches, Education, Society and Water Power, we know of no more inviting section for our friends of the cold North . . ."

Northeast Georgia was never a region of great wealth, although wealthy people flowed in and out on a regular basis. The people were always independent, industrious, and hard working. There were a handful who could reasonably be called rich. A fair number were well-off. A large number were said to be "making a living," and some were poor. But everybody had a place to live and no one was starving.

One financially successful old-timer described his economic background this way: "I guess by today's standards you would say I grew up poor, but I didn't know that then because I didn't have anything to compare with. We did okay." And then he added, "In many ways I wish my grandkids were as rich as I was growing up."

10. Education, Mountain Style

Just behind the desire to own land, there is ample evidence that the widespread desire for an education came to America with its early settlers. Royalty, the wealthy, the social elite in Europe were well educated and saw to it that their children were also. An education was viewed as a passport to respect, power, and financial success. There is evidence also that this attitude followed in the mindset of the not-so-wealthy who traveled the Great Wagon Road and came to settle in North Georgia. If the parents did not show an interest in education for their children, several churches did. Obviously, this strong desire for an education was not unanimous among the parents who came to the frontier, but a sizeable percentage wanted their family to be educated. In basic marketing terms, there was simply a demand to be met.

Developing a system for meeting that demand, however, came neither easily nor fast. The first organized education outside the home was in the form of "academies," generally a private business formed by a professor or at least someone who had enough education to teach the basics to someone else. These "schools" were being formed in towns and villages in Northeast Georgia probably as early as 1800, and by 1820, records show some form of academy existed in most of the towns of the area. The academies were supported by tuition, paid by the parents.

Education in the rural areas was more difficult. Farms were small and scattered. Money was scarce. Getting good teachers for the rural areas was difficult. Community schools evolved, centered in militia districts. In the 1830s, the State of Georgia established what was generally referred to as the "poor school fund" to be apportioned to each militia district according to the number who could qualify. A sizeable number of one-room schools developed, each within "walking distance" of an adequate number of students to pay for a teacher. This is pretty much the way the education system worked in Northeast Georgia until the 1870s.

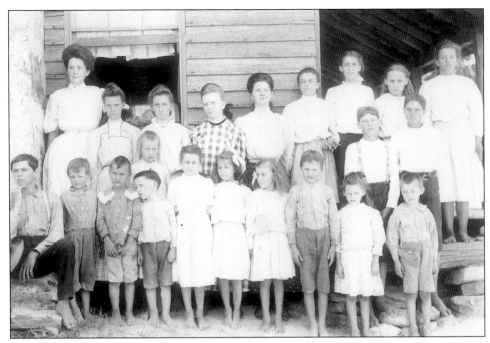

Students pose with their teacher in front of Klondike's Bell School, a typical one-room country schoolhouse, c. 1908.

In the early 1870s, the State of Georgia established the office of the State School Commissioner, and as historian James Dorsey points out in his work regarding Hall County's evolution, "As a result the number of schools increased dramatically, and the number of students educated began to rise."[1] Dorsey reports that in 1877 Hall County had 57 schools for 3,463 white children, and 5 schools for 501 black children. By 1893, Hall County had 71 schools for 4,795 white children and 15 schools for 758 black children. The focus in Hall County, as with almost all rural areas in Georgia, was to have schools as close to farm children as possible even though the schools were small.

In Gainesville, the county seat of Hall County, the emphasis was on building larger, more comprehensive schools. In 1874, the City of Gainesville erected "a ten thousand dollar college building." Not only did it draw students from all over the mountain area, but also "from five different states." Dorsey also comments that "Even though the city owned the building and the school was under the control of the city council, students still had to pay tuition. According to an 1876 advertisement, the tuition per session was $5.50 for the primary class; $10 for the academic class; $13 for the preparatory class; and $15 for what was called the 'college classes.'" This amount was big money in 1876, especially when families tended to have several children.

To compete with the educational leadership being shown by city schools and still keep their students close to home, a number of community boarding schools

were formed throughout the mountain area. In Hall County, Concord Academy, which eventually became Chattahoochee High School, at Clermont, gained a reputation as a leading college preparatory school. There were also boarding schools at Murrayville, Flowery Branch, and elsewhere. In Blue Ridge, the Mary P. Willingham Industrial School for Girls was opened under the auspices of the Womens Missionary Union of Georgia in 1916 with grades 7 through 12. A "finishing school" for women, this school taught art, music, drama, elocution, and social graces as well as "domestic science and home economics." It was closed in 1931.

As the educational advantages of larger schools became apparent, the one-room community schools began to phase out, but in an era when farming was the primary means of making a living and with small farms scattered all over the mountains and foothills, they played a major role in education.

Some highly respected high school and preparatory schools were formed in Northeast Georgia during the late nineteenth and early twentieth centuries, and some unique problems were overcome. Riverside Military Academy, a military academy for boys, was started by Drs. Van Hoose and Pearce, the team which operated Brenau College. The academy was chartered in 1906 after the founding group acquired 25 acres along the Chattahoochee River, just outside Gainesville but on its street railway line. The school was acquired in 1913 by Colonel Sandy Beaver, who had been the head of the University School for Boys, at Stone Mountain. The Beaver years had hardly begun when, in 1916, the school had a devastating fire and a rebuilding process had to begin. By 1923, however, Riverside

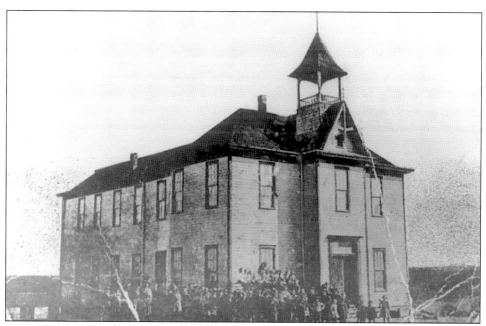

The Flowery Branch school building was constructed c. 1900.

was designated by the War Department as one of ten Honor Military Schools in the United States, and the only one in the Southeast. By then, Riverside had more than 200 students from 17 different states. Its reputation blossomed, and by 1925, Riverside had 451 boys from 31 states.

Not only did Riverside gain a reputation for its military aspects, but also for academic excellence and leadership development. General Beaver acquired a second campus in Hollywood, Florida, and for years, the school held its fall and spring quarters in Gainesville, and its winter quarter in Florida.

During and after the Vietnam War, military schools lost favor, and enrollments dropped. While many military prep schools dropped the military portion of their curriculum at that time, Riverside held fast. The late General Beaver had a reputation as an astute money manager, and even though Riverside does not accept gifts, during the 2000–2001 period, it is undergoing an $80-million renovation and expansion program.

Rabun County was "dirt poor" about 1900; that is the only way to describe it. No paved roads. No railroad. Twenty percent of the voters could neither read nor write. There were 35 community schools in the county, mostly one-room log or weatherboard shelters, where students went three to five months per year. A native of the county, Andrew Jackson Ritchie had struggled and finally worked his way through Harvard, and he had a vision of a school in which mountain boys and girls could work their way through high school in Rabun County. The efforts to get the Rabun Gap School started, and keep it going, are now legend. But Dr. Ritchie, writing in 1948, described the entering class selected in 1903 this way:

> They had to be of very limited means, of sound health, eager for an education, apt to learn, willing to work, and not under 14 years of age.

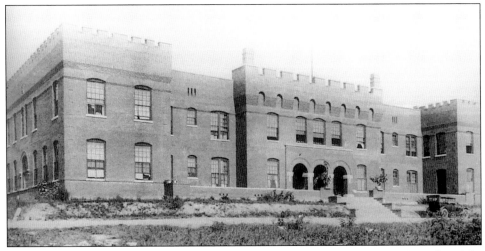

Seen here c. 1919, Riverside Military Academy was chartered in 1906 and purchased by General Sandy Beaver in 1913.

This is the dormitory at Nacoochee Institute. This school building, located at the intersection of Nacoochee and Sautee Valleys, was destroyed by fire in 1926. Nacoochee Institute then merged with Rabun Gap School to form Rabun Gap–Nacoochee School.

> . . . The program for nine months was half the day in school and the other half at work. The fee for tuition was $50 per year. Those who could not pay that sum remained at the school through the summer and paid it in work.[2]

Fifty miles away, at the intersection of the Nacoochee and Sautee Valleys, a similar school for poor boys and girls of the mountain region, called Nacoochee Institute, had been formed under the auspices of the Presbyterian Synod of Georgia, and had developed a campus with several buildings and a strong academic reputation.

The year 1926 was a disaster year for both schools. A fire destroyed the main building at Rabun Gap, and a month later another fire wiped out almost the entire plant at Nacoochee Institute. The two schools merged at the Rabun Gap location, and in the rebuilding gained some unusually powerful financial support. Ernest Woodruff, and later Robert Woodruff, of Coca-Cola, already financial backers at Rabun Gap, became financial leaders in the rebuilding. The work of the combined schools gained the attention and support of the Rockefellers, who drew in other support from the East. The school ended up not only with a new campus, but also with an endowment fund for continuing support.

The Rabun Gap–Nacoochee School has changed through the years, and in the year 2001 had about 250 students from, as one student said, "all over everywhere." But this educational institution holds to its basic principles of hard work, weekly chapel, and disciplined academics.

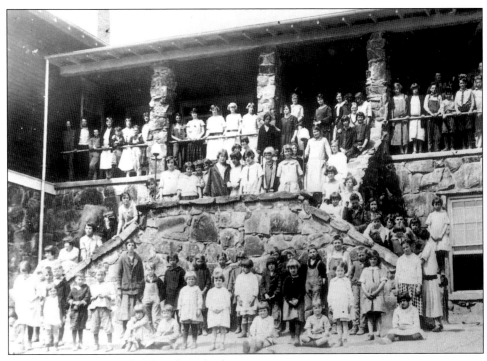

Students pose at the Tallulah Falls School c. 1927.

Another school formed to provide educational opportunities for poor and scattered mountain children, Tallulah Falls School was founded in 1909 by Mrs. Mary Ann Lipscomb, then president of the Georgia Federation of Womens Clubs. Starting with 21 mountain children from Habersham and Rabun Counties, the school in 2001 had 160 boarding students grades 6 through 12. It has evolved with the educational needs of its students and has gained a reputation for educational excellence. Still owned and operated by the Georgia Federation of Womens Clubs as a non-profit institution, the school in 2001 had an annual operating budget of $3.9 million and an endowment of $23 million.

While the University of Georgia was developing in Athens as the state university and land-grant college, and Georgia Tech was being formed in Atlanta as the state's technical school, and the wealthiest private universities (Emory, Mercer, and Oglethorpe) were growing, four small, and at-times struggling, colleges began to fill the needs for higher education in the mountain region. They were started in the late 1800s and early 1900s, a time when higher education was beginning to gain acceptance in the South.

During Georgia's gold rush, a U.S. mint was built in Dahlonega, Georgia. The mint was closed during the Civil War, and William Pierce Price, then the congressman from the Ninth District of Georgia, persuaded Congress to give the old mint to the State of Georgia "for educational purposes." As outlined by William Pittman Roberts (a college history professor fondly called "Wild Bill" by

his students) in his book *Georgia's Best Kept Secret: A History of North Georgia College*, leaders of the college negotiated to have it made a branch of the University of Georgia, thus helping gain support from the university's status as a land-grant college.

The school was opened in 1873 as the North Georgia Agricultural College, a land-grant school of agriculture and mechanical arts, particularly mining engineering. It opened with 177 registered students: 98 men and 79 young women. Interestingly, it became the first state-supported school to grant a college degree to a woman. Although its curriculum was primarily liberal arts, it was not until 1929 that the name was changed to North Georgia College. Although the college has prepared students for all walks of life and has been known as a leading teaching institution for teachers, it has gained its primary reputation as the military college of Georgia.

It was in 1875, according to William Roberts, that "Senator John B. Gordon, Georgia's most popular Confederate hero, persuaded Congress to give the college military equipment and an instructor." Military training was underway. Then, in 1916, Congress formed the Reserve Officer Training Corps and "the North Georgia cadet corps became a part of it."[3] In 1920, 180 graduates were commissioned as officers.

Male students at North Georgia College were required to participate in the military program until 1972, and women were accepted into the military program

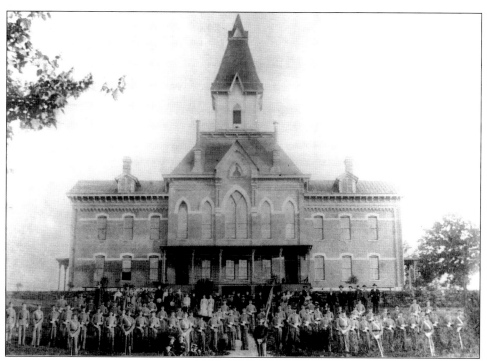

The Corps of Cadets pose for this c. 1900 portrait at North Georgia College.

in 1974. The first female was commissioned in 1974. The school has provided officers for the United States Army during the Spanish-American War, World Wars I and II, Korea, Vietnam and the Gulf War, and has become recognized as one of the leading military colleges in America. In 1996, it was renamed North Georgia College and State University—the Military College of Georgia.

Brenau University was founded in Gainesville in 1878 as the Georgia Baptist Female Seminary, and in 1890, it was renamed the Georgia Female Seminary and Conservatory of Music. Like most educational institutions during the period, the seminary had its financial ups and downs, but began to stabilize after Dr. A.W. Van Hoose became president in 1886.

During that period, Gainesville was a summer resort, and although the town had an opera house located on the square, it was felt more seating and a finer auditorium was needed. Thus, the college and the citizens of Gainesville raised money and built what today is known as Pearce Auditorium, a facility following the design of European theaters of the late 1800s. A journalist for the *Gainesville Eagle* at the time commented that "No city in Georgia outside of Atlanta has such a music hall as is this new auditorium. Only the 'Grand' in Atlanta can compare with it." The auditorium became the meeting place for Northeast Georgia, bringing to its stage not only great music, but also Chautauquas (special educational and spiritual festivals) and nationally-known orators.

In 1900, the name was again changed, this time to the Brenau College and Brenau Conservatory. The school gained a national reputation, both for its music and as a southern women's college, and has continued its growth through the years.

In recent years, Brenau has carried out a major building program, expanded its educational offerings, and changed its name to Brenau University, reflecting the fact it is now a coed institution with several colleges.

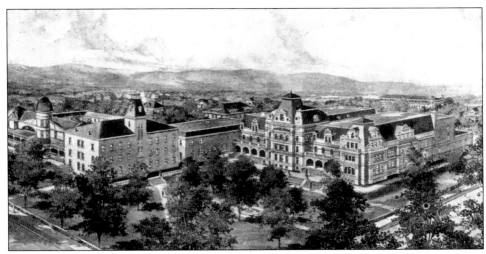

Brenau College-Conservatory is seen here in this c. 1912 line-art depiction.

Signor Governale (left) poses with his violin students at Brenau College in 1900.

Young Harris College was founded in 1886 by a circuit-riding Methodist minister named Artemus Lester, and was soon adopted by what is now the North Georgia Conference of the United Methodist Church. The young preacher had been assigned to four mountain churches in the Towns County area, and was appalled to find there was no school for local children. So, he received permission to use an empty store building and started one. Obviously, there was a need and a desire for education in the mountains, for the church records in 1887 show an enrollment of 75 and a faculty of 4. The school provided primary and secondary instruction as well as the collegiate program, and as late as the 1920s, it had more students enrolled in the primary and secondary programs than in the college. The high school program continued until 1958.

Although started in a log storehouse, the college has expanded to include a multi-million dollar campus, tucked away in some very beautiful mountains. The school embraced new technology early on and has a complete fiber-optic network in place throughout the campus, and at the turn of the century was working to establish wireless access, video conferencing, and video e-mail.

The school remains affiliated with the United Methodist Church, and religious life remains an integral part of its program. From the early days of compulsory daily chapel, the college has evolved to its present multifaceted program of worship, Christian concerts, spiritual life retreats, fellowship groups, and service projects. Young Harris College takes pride in making a claim that few institutions

This early building became the center of Piedmont College in Demorest.

of higher education can make: it provides 100 percent of a student's demonstrated financial need.

Piedmont College is located in Demorest, Georgia, and historically, it is difficult to separate the college from the town. Demorest was formed in the late 1800s as a planned community and marketed all over the United States. It offered a healthy climate, beautiful scenery, and economic opportunities, which, during that era, many communities in the southern Appalachians could provide. But it was another feature that set the tone for Demorest: the founders and developers were prohibitionists, and they wanted a community that was free of whiskey and all its influences. It was the latter that drew families and industries from North and South.

Several of the more prosperous residents of the community wanted a college, so in 1897, the J.S. Green Collegiate Institute was formed, and shortly thereafter, it was renamed J.S. Green College. According to Mary C. Lane's *History of Piedmont College*, the school was "founded and existed from 1897 to 1901 under the auspices of the Methodist Episcopal Church, South."[4] But by 1899, J.S. Green College was facing financial difficulties.

About 1900, the Congregationalists had an active missionary program in Georgia. As a church, they had a long record of interest in education, so supporting a young college would not be unusual, but in Georgia, they needed more. They were opening churches and needed a good college to train ministers. Several of Demorest's leading citizens were Congregationalists. So, in 1902, the name was changed to Piedmont College, and in 1903, funding was obtained through the

Congregational Churches of America. Piedmont College historian Mary Lane notes the following of the college's evolution:

> In a perceptive article written in 1905, John C. Campbell, President, Piedmont College, set forth the Piedmont College mission and its larger implications:
>
> "What means this strangely interesting juxtaposition of men and things? What means this strategically situated school of Northern and Southern teachers that has come under American Missionary Association auspices?"
>
> "Does it mean that we are here to begin a work that shall break down the last barrier of sectionalism and abolish all feeling of caste within our own race? God grant that it be so . . ."[5]

Still associated with the Congregational Christian Churches, Piedmont College has continued to serve students of Northeast Georgia, developing through the years as a liberal arts school and expanding its campus at Demorest. In the year 2001, it had 1,800 students on two campuses.

Great emphasis was placed on public education at all levels and throughout Georgia immediately following World War II. Elementary and high schools, many of which still only provided 11 years of education, added the 12th year. Elementary, middle (junior high, it was usually called), and high schools became larger consolidated schools, and the small community schools were closed. Junior colleges and vocational-technical schools were built all over Georgia, and Northeast Georgia got its share. Private colleges appeared, such as Truett-McConnell College, in Cleveland, and private preparatory schools, such as Lakeview Academy, in Gainesville. The improvement of education itself, the development of roads and vehicles to travel over them, and the improvement of the economic status of Northeast Georgians have given the people of the mountain area educational opportunities on a par with anyone, anywhere in the rest of the state. That wasn't always the case.

11. The Industrialization of Northeast Georgia

The era of industrialization took place in America in the late 1800s, most of it in the North and Midwest. Historian Arthur Cecil Bining, of the University of Pennsylvania, states, "there were only thirteen works [in the United States] that produced 11,838 tons of steel in 1860. It was after the Civil War that the development of major steel mills blossomed in New York, Pennsylvania, Massachusetts and Ohio."[1]

The cotton industry in New England had developed the first large American industrial plants, and sizeable sawmills for lumber and railroad ties had been established in places like Upstate New York. Not only were the markets for "cottage industries" taken over by large industrial mills, but similar industries started clustering in certain areas: boots and shoes in New England; coal and iron in western Pennsylvania; lard in Ohio; and lead in Wisconsin.

Mass manufacturing led to the development of mass marketing, and just before 1900, a flurry of consumer products was introduced, their sales supported by widespread distribution and promoted by advertising in mass-circulated publications. Things like a mechanical apple-peeler, a new style egg-beater, and a hand-cranked clothes-wringer were promoted over a national market. Most of these new mass-marketed consumer products came from the North, with at least one major exception: Coca-Cola, from Atlanta.

For the most part, however, the South remained a cash-starved agrarian land. Along the fringes of the Blue Ridge Mountains of Northeast Georgia, especially along railroads when they were laid out, a number of industrial-size manufacturing plants were developed before 1900—plants like Atlantic Steel Company, in North Atlanta.

One of these industrial-era manufacturing plants was the Bona Allen Company, of Buford, Georgia, which was founded in 1873. Bona Allen became one of America's largest tanners and manufacturers of leather goods, and spawned a number of smaller specialized companies in the region, like the Flor Saddletree

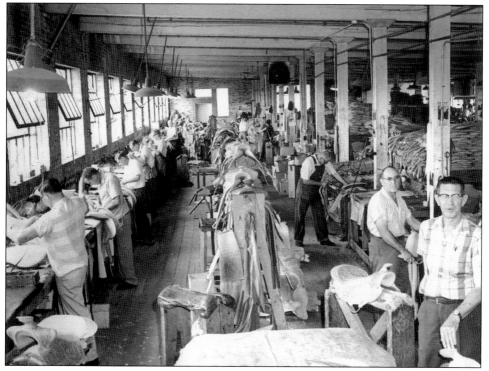

Workmen make saddles at Bona Allen, Inc. c. 1965. This leather-working factory was founded in 1873.

Company, in Demorest. The Bona Allen Company gained a worldwide reputation for fine leathers, saddles, riding equipment, and harnesses before it declined in the face of the automobile, and was sold in 1960.

The mountains and foothills of Northeast Georgia did not fit the pattern of industrial-age development, but Gainesville, located on the edge of the mountain area and with a major north-south railroad, was a possibility. And thus, in 1900, the big industrial mills came to Northeast Georgia.

Textiles, the heart of New England's original industrial revolution, have often been referred to as "America's first basic industry." During the last half of the 1800s, Massachusetts dominated the textile business, and all New England was true to its English heritage as a leader in world textiles. Historian Arthur Bining reported that in 1860 the value of manufactured cotton goods produced in the United States was $115,500,000. Of this, New England and the middle states produced $105,500,000 and the South $8,500,000. The rest was scattered and insignificant. Then, about the turn of the century, the American textile business saw a great spurt of growth in its world markets, mostly in cotton goods. At the same time, New England was running short on labor, and beginning to see the first organized dissatisfaction among its workers. The combination of growing markets, which called for new mills, and an unstable labor force caused

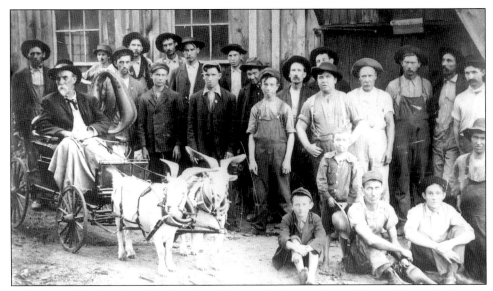

Robert H. Allen, brother of the founder of the massive leather factory Bona Allen, rode through the works in a goat-pulled cart.

New England capitalists to reevaluate the New England operating base for textile manufacturing.

From 1900 to 1930, there was a great exodus of textile mills from New England to the South, mostly into the piedmont region of North and South Carolinas. In 1900, Massachusetts was the undisputed leader in U.S. cotton manufacturing plants, with most of the rest in other New England states. Only 20 years later, in 1920, Massachusetts had 231 textile plants, and Rhode Island, 132—for a total of 363. North Carolina, South Carolina, and Georgia, by that time, had 588 textile manufacturing plants, mostly new with the latest technology. From 1900 to 1920, cotton manufacturing in the United States increased 85 percent; in cotton-growing states, the increase was 255 percent.

There were many advantages for locating a cotton mill in the South. A promotional booklet published by the Georgia Railway and Power Company listed them all, in detail: a mild climate, lower building costs, lower taxes and operating costs, lower wage rates, dependable electric power, and always, dependable labor. New England had become the recipient of many immigrants, with mixed feelings among both the newcomers and the old-timers. One of New England's newspapers commented at the time that "This is one reason cotton mill interests are locating southward, where they will be sure to find native American workers like the pioneer mill operatives who, fifty or sixty years before the invasion of foreigners, made New England famous as a textile center." The New Englanders saw in "the mountaineers of the Southern Appalachians" a people similar to those hardy pioneers who had settled their own land. The *North American Review*, in discussing these people's attributes, states, "They are

proudly independent and high spirited . . . chiefly of Scotch-Irish ancestry"—not to mention the fact that they were hardworking people who put in 60-hour weeks with pride.

There was one eternal problem, however. It was not enough to build just a cotton mill; one also had to build a mill village. In an age when the fastest mode of local transportation was a horse and in an emerging age of multi-shift manufacturing plants, the work force had to be nearby—preferably in walking distance. From a geographic standpoint, mountainous Northeast Georgia did not fit the pattern of cotton mill development. But its tumbling streams could produce power, and its people both wanted the work and were prized workers. Thus, Gainesville became home to three major textile manufacturing plants and three mill villages, economic dynamos that added to the wealth of the region and filled employment gaps as other enterprises declined. Gainesville Mill and village was constructed in 1899; Pacolet's New Holland Mill and village was opened in 1901; and Chicopee Mill and village opened in 1927. These mills would be followed by others, such as Owen Osborn's hosiery mill in 1933, but by then, the automobile made it unnecessary to build a village adjacent to the mill.

John A. "Dutch" Webb, in his mostly pictorial *History of New Holland, Georgia*, notes the economic impact of Pacolet's New Holland mill and village was immense. At the time, Gainesville's population was about 5,000 people. New Holland village added houses for about 225 families, with 1,400 people in all. A sizeable percent of these new residents came into Gainesville from mountainous counties to the north.

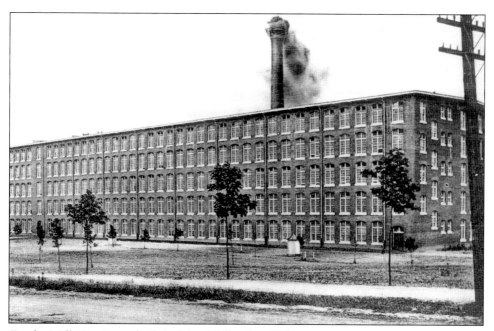

Pacolet Mill No. 4 was built in New Holland c. 1901.

The New Holland mill village included a church and a recreation building, which had a swimming pool in the basement. This photograph was taken c. 1940.

Even though the impact was great on the economy of the area, the impact was greater on the individuals, the people who came off the marginal farms and entered a new way of life as well as a new occupation. For them, this was a dramatic change. The 1923 book *Industrial Georgia* observed, "they have migrated willingly into industry. Hardened to much rougher work at home, they have regarded the life of an operative as one of comparative ease at an interesting task. They have looked upon this life, with schools and churches and stores and doctors close at hand, as offering many things that had been denied them by their seclusion."[2]

It seems fair to observe that Gainesville was fortunate in the companies that chose to locate on its outer edges. Gainesville Mill's village was fairly standard for the time, but nicer than many and certainly nicer than most homes to which the new workers had been accustomed. New Holland was unique in that it was built at a former resort location, with springs in place and some recreational areas already in place. But Pacolet proudly added all kinds of top-rate amenities that made living in this village a "family" affair, with championship athletic teams and architecture that stands apart even today—they even had an indoor swimming pool.

But it was Chicopee that gained national attention for its village. Built toward the end of the mill village era, Chicopee was literally a prototype for modern-day

subdivision development. A Chicopee publication of the 1930s states proudly, "It is a village of beauty, healthfulness and home-like comfort." Its streets wound up through the hills, had underground wiring, ornamental streetlights, and landscaped grounds. There were two churches, a store, a school, a community house, and a swimming pool. There were 250 brick homes, of 31 different designs—"each has individual distinction and possesses none of the sameness and monotony so often found in mill communities." Every home had a bath, and cleanliness was a tenet of the mill and its people. Chicopee Village could accommodate 1,500 people in the families of 500 workers in the mill. It set a new standard for the working people of Northeast Georgia.

The Southern states never fully participated in America's great Industrial Age, and Northeast Georgia is not an industrial area even today. But it was the coming of the cotton mills, along the railroads on the edge of the mountains, that gave this region a taste of mass manufacturing. The cotton mills made a major difference in the economy of Northeast Georgia, and the villages turned out many noted sons and daughters. Probably more important, the cotton mills added to, and diversified, the economy at a time when it was sorely needed.

This Chicopee Mills baseball team won the Northeast Georgia Industrial League championship in 1929.

12. TIMBER, LUMBER, AND LAND

In the late 1800s and early 1900s, America staged a building boom that ate up a tremendous amount of the vast forests in the Eastern United States. Most homes were built of wood, and it was a time when major urban areas were being developed—a time when people moved from farms to cities to fill the new industrial jobs. Factories of that time were usually of brick exterior construction with heavy wooden flooring inside, and usually several stories high. Had it just been constructing factory buildings as America industrialized and subsequent homes for the workers, there would have been a skyrocketing demand for lumber. But there was another massive wood eater, too, and that was the expansion of the railroads. The railroads used wooden railroad ties, and for every mile of railroad laid down, a small forest was required. Railroads probing across the Great Plains brought in their railroad ties from the East. And a lot of the forests of the Northeastern United States had already been cut over. The lush forests of the Southeast were ripe for harvesting.

Norman Bruce Alter, in his unpublished 1971 study of the Chattahoochee-Oconee National Forest, reported, "As early as 1888, a Mr. Thrash came into the Toccoa River area and bought choice trees for fifty cents each. . . . It is told that many boards cut from Poplar logs were wide enough to occupy all the four foot space between standards of the lumber wagons." Other groups and individuals actively bought trees. But before a company would invest the heavy capital required to build a lumber mill, they would usually seek to own large tracts of forest land to assure a stable, continuing supply of timber.

Timber companies, therefore, began to buy large acreages of North Georgia mountain property. By 1902, the Pfister and Vogel Land Company was actively buying land for $1 per acre and ended up with more than 80,000 acres. Gennett Lumber Company was active early. The Alaculsy Lumber Company was buying land as early as 1900 and owned some 60,000 acres—mostly in Murray, Fannin, and Gilmer Counties. There were other major land purchasers through the years

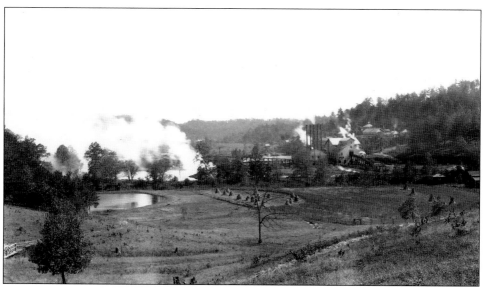

The Byrd-Matthews Lumber Company (later Morse Bros.) sawmill dominated the peaceful valley at Helen, Georgia, in 1914. Note the five smokestacks and escaping steam.

including Oaky Mountain, Conasauga River, Blood Mountain, Bert Mathews Acid Wood Company, and Smethport Extract Company.

But none bought as actively, logged as aggressively, or had as much impact on the economy of Northeast Georgia as the Byrd-Matthews Lumber Company—later to become the Morse Brothers Lumber Company. Information is sketchy on how a group of St. Louis businessmen, who had made their money in the flour milling business, got interested in building a lumber mill in Northeast Georgia—but they did. They built one of the largest lumber mills in the Eastern United States in Helen, Georgia. The company bought adequate mountain forest land to ensure a large supply of logs. They became the major stockholders in a 37-mile railroad from Gainesville to "North Helen," necessary to get finished lumber from the sawmill to connecting railroads and thus to the markets of America and the world. And before it was over, the company built 150 miles of small railroads into the forests to haul logs to the sawmill. It was a massive enterprise.

The size of the Byrd-Matthews Lumber Company mill building was said to be "a shock" to people arriving in town after riding the train through long stretches of low mountains with few signs of civilization. Behind the mill stood five round, skyscraper-high smokestacks, each driving a 100-horsepower stationary boiler built by Baldwin. One 150-horsepower engine ran everything in the mill, and the leather belt that ran the sawmill itself was said to be 5 feet wide. Another 75-horsepower engine provided power for the town of Helen. It was a two-band sawmill, probably the only one in the Southern United States at that time, and at full capacity, the operation could turn out 125,000 board feet of lumber a day—enough to build nine sizeable frame dwellings.

But apparently the Byrd-Matthews people made some mistakes in their planning, and things did not go well. They chose the wrong type of railroad engines to get the logs out of the forests. Anna Ruby Falls became a major stumbling block in moving logs from a major supply area to the sawmill. Even the market softened. One modern-day survivor of the era was quoted as saying, "As lumbermen, they were pretty good flour millers."

In 1917, the enterprise was acquired by the Morse brothers, a family of experienced lumbermen from Upstate New York. In the 1800s, one William Morse had founded a lumber company in New York State, and it was seven brothers, all grandsons of William, who came to the mountains of Northeast Georgia and took over the troubled lumber company. Morse Bros. Lumber Company put slower but more powerful narrow-gauge railroads into the forests to bring logs to the mill, made a number of changes in the mill itself, and soon had the huge sawmill humming. They also were perfect in their timing, for with the beginning of World War I, the market for lumber exploded. With sharply increased demand, prices went up, and the dollars flowed into the company.

Morse Bros. Lumber Company was the primary job provider in Northeast Georgia's mountains for a period of time. In Helen, some housing was built for the people who worked in the sawmill. But throughout the mountains, jobs were provided for local people who did everything from cutting trees to running railroads. The Morse management was proud that as long as the sawmill was in operation, they never missed a payday.

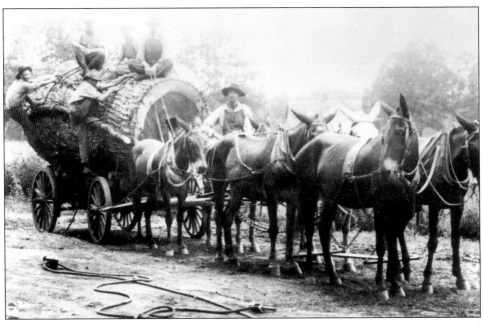

This huge log was cut near Lawrenceville c. 1915. Many mountain chestnut trees produced planks 4 feet wide.

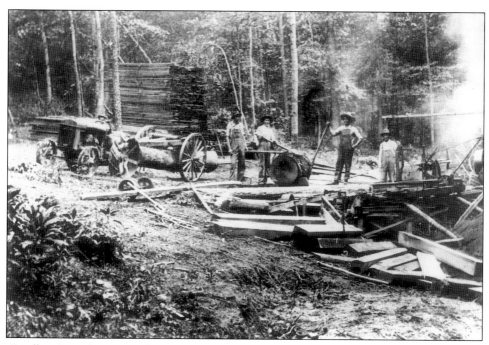

Small independent sawmills were dotted throughout the mountains in the 1930s. Note the tractor (at left), which replaced horses, mules, and bulls.

By 1928, however, the big mill had cut off most of the virgin timber in its circle of operations. Actually, they still had more land that had not been logged, but its location made it unprofitable to cut and transport to the mill. So the tough decision was made: they would close the sawmill in Helen, Georgia. And they did. The equipment was sold and shipped to Mexico, where another lumber enterprise was being formed, but local tradition says it never went into operation.

The lumber business continued as a part of the economic picture in Northeast Georgia, but never again at the level provided by the Morse brothers. Charles Maloof and a Mr. Miller acquired the five boilers left by Morse and restarted a sawmill in Helen. Eventually, it was sold to Cliff Blalock, and it continued until a tragic fire shut it down. Several small sawmills and a number of specialized companies, making such things as veneer, dogwood shuttle blocks, and hardwood flooring, have been important in the area.

With much of America's Eastern forest lands cut over, and the lumber industry scaling down significantly, a question remained: what would happen to the mountainous lands of the Appalachians?

Natural erosion had brought the Appalachian Mountains from their high of 30,000 feet down to 6,000 or less, and as the area matured, it had become a densely forested land with ample game and a rich but thin layer of topsoil. Now, several practices threatened to destroy the forests and speed up the erosion. First, the Indians had practiced annual "burns" to kill underbrush in wooded

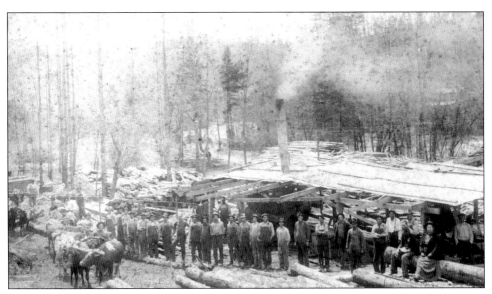

Mountain sawmills provided jobs for a lot of people across Northeast Georgia.

areas, and to kill ticks and other insects, as well as weed seeds, in cultivated fields and pasture lands. At times, they burned simply to make it easier to pick up the chestnuts. They also had used fire to herd deer into areas where they could be more easily killed for their hides, and some of these fires had apparently burned large mountainous areas.

The European settlers had continued the practice of burning off cultivated fields, often burned woodland, and especially pasture land, to eliminate undergrowth and to encourage the sprouting of more tender green shoots for grazing in the springtime. Stripping the steep slopes of the virgin timber, however, brought entirely new threats. Sheet erosion left mountains incapable of growing cover, let alone forests, and the resultant floods filled streams and rivers with silt. In an age when Americans fully expected their natural resources to last forever, there developed an era of concern for the well-being of the mountains of the Eastern United States.

Gifford Pinchot, in *Breaking New Ground*, credits Professor Joseph A. Holmes—then state geologist of North Carolina and later director of the U.S. Bureau of Mines—with originating the idea about 1892 of an "Eastern Forest Reserve" owned by the federal government. Various groups promoted the idea, but it did not become an "agenda item" in Washington until 1901, when President McKinley mentioned it to Congress, and a year later when President Theodore Roosevelt championed the cause in his annual message to Congress. Even so, it was not until 1911 that the Weeks Law was passed authorizing the purchase of land, and national forests became a reality in Virginia, North Carolina, South Carolina, Alabama, and Georgia. The new federal program was to have a major impact on Northeast Georgia.

Land purchases by the National Forest Reservation Commission were started in 1912 and the availability of large tracts of logged-over land allowed acquisition to move rapidly. In fact, many people who were close to the development of the Eastern National Forests contend that without the original acquisition work by the private timber companies in buying many small pieces of land to put together large tracts, development of the National Forests would not have been possible.

It is likely, also, that without removal and sale of the timber, much of the land would have been priced out of the government's range. The first bill, in 1901, proposing land purchases for a forest reserve, recommended $5 million for the purchase of not less than 2 million acres of land. From the beginning, there was a cap on what the government would pay, and the intent was to acquire as much land as possible with the dollars allocated by Congress.

By 1917, the "Savannah Purchase Unit" alone—meaning the Savannah River drainage area—owned 539,702 acres in Georgia and North and South Carolina. Many of the lumber companies sold their land to the government with much of the virgin forest intact. Pfister and Vogel was said never to have cut any of their 80,000 acres, and sold it all to the federal government. The 1971 Alter study reported that three companies, Conasauga River Lumber Company, Blood Mountain Lumber Company, and Morse Bros., sold 138,338 acres of land to the government from 1927 to 1935 at prices ranging from $1.50 to $4.75 per acre.

The federal government has continued land acquisition, on a much more modest scale, through the years by direct purchases. But, it has also gained a good

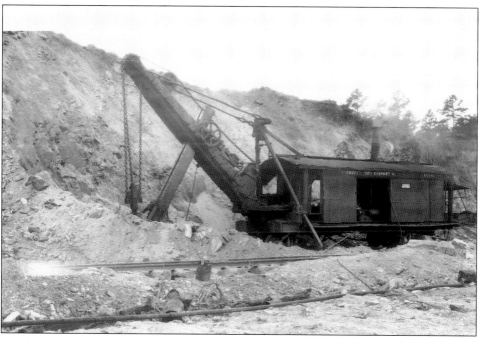

Sand and gravel are being loaded by steam shovel from a railway ballast pit near Alto c. 1919.

deal of property through swaps with other landholders such as Georgia Power Company and through reassignment of land from other government entities such as the Tennessee Valley Authority, the Resettlement Administration, and the Farm Security Administration. In 1936, President Franklin D. Roosevelt, by presidential proclamation, set aside a large section of land in North Georgia and designated it the "Chattahoochee National Forest."

The legacy of the timber and lumber era, followed by the development of the national forests, is simple: today, 750,000 acres of choice mountain land in Georgia, an area larger than the entire state of Rhode Island, is set aside for managed forestry, wildlife and hunting, and recreation. Game management and hunting on National Forest land began in 1924 under President Calvin Coolidge. Norman Alter reports, "The improvement in big game hunting has probably caused more people, both in and out of the forest area, to look with favor on the National Forest than any one factor in forest management in the last 25 years."

The Chattahoochee National Forest is the closest mountain playground not only to Atlanta and other inland urban areas, but also the coastal areas of South Carolina, Georgia, Florida, Alabama, and Mississippi. Few other areas in the world have this much undeveloped, beautiful mountain land so readily available to large population centers.

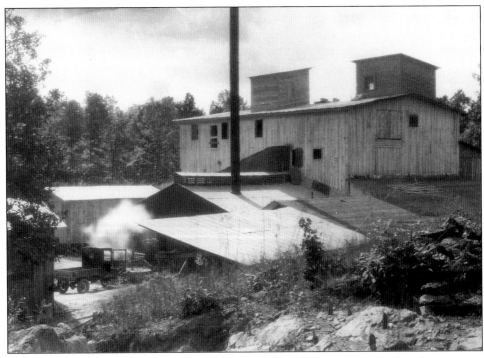

This is believed to be the manufacturing plant of the Asbestos Mining and Mfg. Co. near Hollywood in Habersham County in 1926. A good amount of asbestos was mined in Northeast Georgia.

13. A Time of Adversity

Economically, the period from 1900 to 1930 was fairly comfortable in Northeast Georgia. The ravages of the Civil War had subsided, and new developments were popping up. Thriving businesses were evolving. Stately homes were built. Schools were started or expanded. The end of World War I left the entire nation with a euphoria, a sense of well-being, that came to a sudden and brutal end with the Wall Street Crash of 1929. There was, however, more to the economic problem in the mountains of Northeast Georgia than merely the Great Depression, devastating though it was. This region was caught up in a series of economic trends that were much more on the adverse side than the positive side, and the cumulative effect was a downward spiral.

For instance, the boll weevil was devastating to the cotton farmers, and although Northeast Georgia was not considered a major cotton-producing area, cotton was the major crop. And farming was still the number one source of income. As cotton slid downward as a cash crop, it not only affected the area's farmers, but it affected almost all businesses. Cotton was still the economic engine that drove the region. Many towns would be filled at harvest time with bales of cotton, for a number of major cotton merchants operated out these areas, such as Gainesville. The agricultural community (farmers, farm supply dealers, cotton merchants, hardware stores, bankers, and others) was accustomed to bad years now and then when a drought hit. But the boll weevil was now hitting every year, and nobody knew what to do about it. County agents were promoting pastures and cattle raising. Farmers all over the nation were in a bind, and Northeast Georgia was no exception. Studies made by the Agricultural Extension Service at the time noted that for every dollar income created by farming, there was an impact of seven dollars in town. The idea was that the farmer spent the dollar with a merchant, who deposited it in the bank, or spent it for the doctor, who bought a new car and on and on. In reverse, money which did not come to the farmer was devastating for the entire economy.

This is an aerial view of Gainesville's downtown business section shortly before it was leveled by the Tornado of '36.

On top of that, some insist one of the most devastating developments of that era was the coming of the chestnut blight. It is estimated 30 to 40 percent of the trees in mountainous North Georgia were chestnuts, majestic trees that often had a diameter of 5 to 6 feet. Not only were they a major source of lumber, but they also provided tannic acid, and in the 1920s, one of the major industries in Helen, Georgia, was the Smethport Extract Company, a major producer of tannic acid. The nuts from chestnuts and chinquapins were fall cash crops for the mountain farmers, and most weekends farm families could be found in the towns with wagonloads of the succulent nuts for sale.

It was determined that the chestnut blight came into New York harbor from China and was discovered in Central Park in 1904. It spread throughout the Eastern United States, coming down the Appalachian mountain range, as one ranger said, "like a fog." The blight began to affect the chestnut trees in Georgia's mountains in the late 1920s, and by about 1930, almost all of the chestnut trees in Northeast Georgia were dead. The same blight that destroyed the chestnuts also killed the chinquapins.

As the forests were harvested in the mountains, and as the chestnut trees died, the lumber business declined. Dr. Tom Lumsden in his book *Nacoochee Valley* commented that "The last of the virgin stands of timber were decimated by 1928 and the demise of the mill and the railway brought to Nacoochee its own private preview of the depression."[1] It was not just the timber that was lost. A goodly

number of mountain men made a living working in the forests for the logging companies, and others had steady employment in the sawmills and with the railroads that hauled the lumber. Jobs were lost, too.

Gold never made a comeback after the Civil War, primarily because the only ore left was low grade and it was impossible to mine it and make a profit. Other minerals were not plentiful enough to warrant the investment in mining.

The tourist business took a big hit, too. The depression kept customers from flocking to the mountain resorts, and the local tourist industry thrives best in an affluent society. The trends had been running against it even before the crash. One of the great medical finds of the early 1900s had to do with the fact mosquitoes spread malaria, and with the dreaded fever controlled, coastal areas, such as South Florida, gave the mountains heavy new competition for the tourist and second-home business. In Gainesville, the use of automobiles caused the demise of the trolleys, the truly unique system that linked all the summer activities together. In 1925, the Hunt Opera House, that fine three-story brick building with its arched windows and grand style, burned to the ground.

Highways and motor vehicles took from the railroad industry a dominance of transportation, and America's blooming love affair with the automobile totally changed summer vacation and holiday patterns.

And to add insult to injury, the Prohibition Amendment—which had been passed in 1919 and had created somewhat of a boom for the moonshiners of the mountains—was repealed in 1933. Legal whiskey was on the market again,

Located at the corner of North Bradford and Washington Streets in Gainesville, the Hunt Opera House burned to the ground in May 1925 as a large crowd looked on.

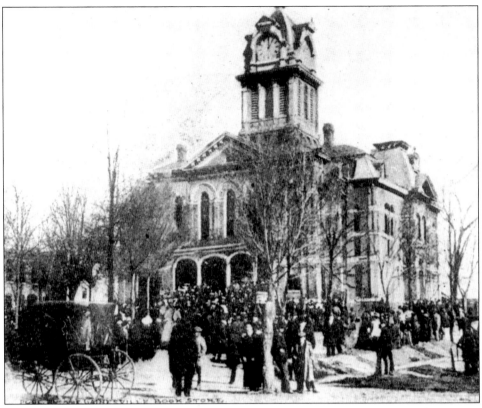

The Hall County Courthouse is seen here in 1912; it was later destroyed by the tornado in 1936.

even though it would be after World War II before a person could buy it in most Georgia counties.

But, it was what the insurance people call an "Act of God" that dramatically changed Gainesville, the region's business center, and in so doing set the stage for a new economic direction for the northeast corner of Georgia. It was on April 6, 1936, that Gainesville was hit by the worst tornado recorded in the United States up to that time.

Step by step, it would appear, the economic underpinnings of Northeast Georgia were being whittled away—the boll weevil, the chestnut blight, control of the "bilious fever" along the coast, legalized whiskey, the national depression, and now a tornado. In the business world, there are times of great structural change—not cycles, mere ups and downs of the economy—but permanent change that happens gradually over a period of time. These changes often are not dramatic, are hard to see at the time, and thus rarely make the news. As one mountain man noted, "It is sort of like cutting a hound's tail off one inch at a time. It hurts a little bit every time you chop; but it takes a while before you see what is happening, and quit wagging."

Gainesville's Tornado of '36 was very visible—front-page news, worldwide. The sesquicentennial edition of the *Times*, of Gainesville, recorded it this way: "A slashing, tearing triple tornado, the third on record, cut Gainesville to the quick shortly after 8 o'clock [a.m.] on the almost midnight-like morning of April 6, 1936." One local survivor described the awesome noise as "like a dozen freight trains thundering down the street at full throttle." Major daily newspapers across America declared that Gainesville had been leveled, devastated. They described Gainesville before the storm as "a prosperous little mountain trading and mill town."

W.M. Brice, the Gainesville correspondent for the *Atlanta Journal* and Associated Press at the time, later described the storm in his book *A City Laid Waste* as follows: "Traveling with almost inconceivable velocity, carrying within its bosom a death-dealing vortex whose power can only be estimated by the destruction wrought, the tornado ripped through the heart of this quiet, beautiful little city—rending, tearing, ripping, wrenching, laying waste practically everything within its path." Brice estimated the property loss at $16 million.

To this day, there is still discussion about how many were killed. There were visitors in town, and some families were completely wiped out with no record made of their losses. But the official report from the U.S. Weather Bureau

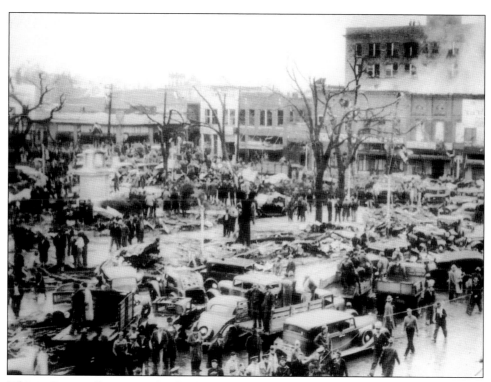

This is Gainesville's square shortly after the Tornado of '36. Note the smoke from the burned-out buildings.

said 203 people were killed; 934 were injured; and damage was estimated at $13 million. The Red Cross said 139 homes were totally destroyed, 198 were seriously damaged, and 2,094 families were affected. The tornado was described as a "triplet," three tornadoes in one. The first hit Brenau College at 8:27 a.m. and moved on to New Holland Mill, where it removed the top floor. There was serious damage, but amazingly there were no casualties. The second came from the west, riding astraddle Dawsonville Highway straight for the business center of town. The third came from the southwest, close to the Atlanta Highway. When the latter two came together, they were almost on top of the Gainesville square. The clocks stopped at 8:37 a.m.

The devastated area was 8 miles long, and varied in width from one-half to 1 mile. The local paper later reported the following:

> Nearly everything in an area four blocks in width in the heart of Gainesville exploded in ruins. Buildings crumbled like paper boxes. Stones, bricks and mortar man had used to shelter businesses and families fell before the onslaught, the square lay in utter ruin and fires finished what the wind failed to destroy.

The greatest loss of life came at the Cooper Manufacturing Company, a pants factory, just off the main square. The building, full of cloth and partly finished pants, was heated by coal stoves. The major sewing room was on the second

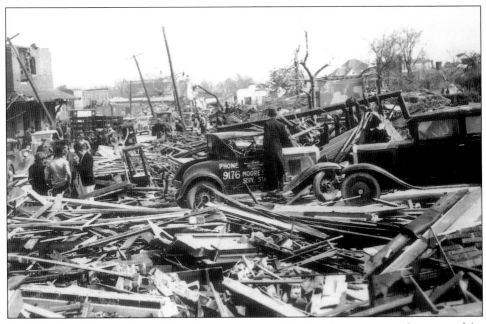

This photograph was taken at the Gainesville Midland railroad station—another scene of the destruction after the Tornado of '36.

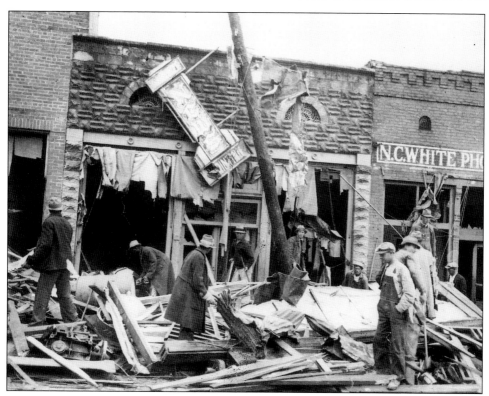

Volunteers begin clearing the street in front of the Gainesville News *and the N.C. White Photography Studio.*

floor, and the workers were just reporting for work. One worker that escaped the disaster said, "The building went to pieces." Apparently the building literally "blew apart" and in so doing destroyed the stairs and other means of escape. Coals from the stoves ignited the cloth, almost with explosive violence, and most of the deaths were caused by fire. At least 60 people died in this one location, perhaps as many as 100.

Three days later, President Franklin D. Roosevelt, returning to Washington from Warm Springs, stopped his train in Gainesville and addressed the people of the town. He was said to have been touched by the devastation, but more so by the proud spirit of the people, and he pledged to help them. In an era of new federal programs, Gainesville became the recipient of a good bit of attention—not to mention federal money. Two years later, Roosevelt returned to Gainesville to congratulate the town on its indomitable spirit and its progress in rebuilding. Thus, Gainesville's tornado aftermath became a shining showcase of the New Deal, an example of how Washington programs could help local communities and citizens in times of adversity.

Because of a tornado that took only three minutes to travel through town, Gainesville lost the majority of its economic base and a large percentage of its

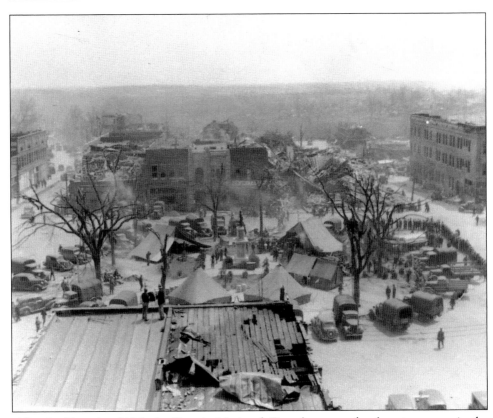

After the Tornado of '36, the Georgia National Guard set up a headquarters camp in the middle of the downtown square. The people lined up at the right were in a food serving line.

unique architecture and character. The business buildings centering around the main square, almost all with distinctive brickwork and classic design, were gone. The hotels were at least partially covered with insurance, and would return in toned down structures, but never again in their glory. Many businesses, like the massive Pruitt-Barrett Hardware Company, never reopened. And many business leaders were either killed, or their businesses damaged to the point that they had to focus totally on survival for today rather than future progress.

The majority of the town's fine homes were destroyed. A few were of antebellum architecture, but most were classical Victorian, a sharp contrast to the Georgia towns that came from a plantation background. Of the almost 400 homes totally destroyed or severely damaged by the tornado, some local citizens believe at least 100 would have qualified for the historic classification in the 1990s. With a few notable exceptions, only the homes along Green Street survived as a reminder of the Gainesville that existed prior to April 6, 1936. Because Gainesville was the business, financial, and transportation center for Northeast Georgia, the entire mountain region had suffered a crippling economic blow. Such was the impact of the Tornado of '36.

14. SELLING CORN BY THE GALLON

The mountains of Northeast Georgia have had severe disadvantages when compared to the economic engines that drove other parts of America. With poor roads and tumbling, non-navigable rivers, trade was difficult. Row crop farming was most profitable on flat, fertile land. The railroads took other routes because of the barrier formed by the mountains. As late as 1997, there was still a hot debate about where to build a good highway from Gainesville to Chattanooga.

But there were advantages, too—most often encouraging enterprises that were not popular in other sections of America. Good deer hunting, and thus an ample supply of buckskins, made this region a center of wealth during Indian times. There were minerals, such as gold, iron, mica, asbestos, and others. The forests provided an entire industry of its own. There were mineral springs which people sought out for health reasons. There were cool temperatures, clean air, and a healthful climate.

There was another advantage, too. It was an ideal area for the production of illegal corn whiskey. Rich bottom land gave a good yield of corn, which often was measured by the gallon rather than by the bushel. The mountains provided ideal hiding places for the production of distilled corn whiskey, and the mountains of Northeast Georgia were not too far from population centers, which provided a ready market for their wares.

There are many recurring themes in the economic history of Northeast Georgia, but none as pervasive as moonshine whiskey. It bobs up in almost every generation, and yet (mostly because it is illegal, and in the Bible Belt considered to be immoral) it is very difficult to dig out supportable facts about it. However, there is a major body of traditional information, some written but mostly passed along by word of mouth, one generation to the next. It is a delightful and colorful history, but factual? Who knows?

The people who settled the mountains of Northeast Georgia were not the wealthy folks. Those with enough money bought plantations along the coast, or

certainly in the piedmont regions, and were mostly English gentry. The mountains were settled by poorer people, fiercely independent and proud, and among them were the Scotch-Irish. Scotch-Irish people were Scotsmen who had been forced out of Scotland and then run out of Ireland to America, often for religious beliefs, but for other reasons, too. Tradition says most in North Georgia came from the Ulster area of Ireland. No matter the route they traveled to get here, these people of Scottish descent carried with them a magnificent ability to make good whiskey. For these people, making whiskey was not an illegal or immoral act; it was a valuable skill and a respected profession.

There are folktales indicating "spiritous liquors" were made in the area while it was still Indian territory. But if it was not made in the mountains, it was certainly a popular trading item and there is ample evidence many Indians traded prized buckskins for a small jar of Demon Rum, or white whiskey. It is also well documented that locally made "spiritous liquors" were a major business during the gold rush. There was a thriving "whiskey cart" business, and every night after the prospectors came in from the cold mountain streams and sat by their fires, the whiskey carts would roll in. These "Twenty Niners" would pay for their whiskey with gold dust.

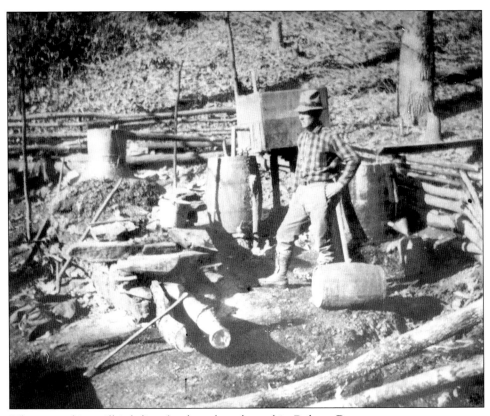

This moonshine still is believed to have been located in Rabun County.

Making whiskey was not an illegal act in this period of time—considered immoral by some, but not illegal. Nor was it illegal in the early days of the health resorts, when—it has been reported—male visitors to the mountain summer resorts enjoyed an "afternoon toddy" as well as an after-dinner drink and cigar. The federal government, in Washington, changed the legal status of whiskey-making during the Civil War. They did not make whiskey an illegal substance, but they decided to control it through licensing and taxation. They should have known better. After all, the United States was hardly launched when, in 1794, the federal government imposed a tax on whiskey makers and that act brought on the Whiskey Rebellion in Pennsylvania and the first serious challenge to the Union. People take whiskey making seriously.

Robert Scott Davis Jr., in his study of the North Georgia Moonshine War of 1876–1877, states, "The federal revenue laws that taxed alcohol and tobacco manufacturing through licenses were first passed during the U.S. Civil War, and imposed a tremendous hardship on Appalachian families."[1] Licenses were intended for large, commercial distilleries—way too expensive for mountain farmers. So, they just kept doing what they had been doing, only now they moved their "stills" into the mountains. That was the beginning of the love-hate relationship that became the "moonshine" tradition in North Georgia.

Following the War between the States, when federal officials got serious about enforcing the alcohol and tobacco laws, a system was established under which federal revenue agents were paid on a "fee basis." The more stills busted and the more arrests made, the more an agent received in compensation. Not only was there a growing dislike for the "Revenooers" because they enforced the federal laws, there was also suspicion, probably with some justification, that some revenuers resold the captured stills after sending the moonshiners to jail.

Davis, in his article on the Moonshine War, said, "By 1876, cases involving the prosecution of revenue law violators virtually monopolized the docket of the Federal District Court in Atlanta, Georgia."[2] The moonshiners began to organize and fight back. Not only did they shoot at some revenuers, they also shot at some members of the 2nd United States Infantry. It was not long after the Civil War, and it was not unusual for the U.S. Army to be in the area. Davis reports, "In 1876, citing the loss of $500,000 annually in Federal taxes and the reports of bands of Moonshiners firing upon Revenue agents . . . President Ulysses S. Grant ordered increased use of the U.S. Army for protection of Revenue Agents."[3]

It was a mistake, and the action triggered the North Georgia Moonshine War of 1876–1877. Not only did the Revenuers have the incentive from a "bounty" system, now they had the backing of the U.S. Army. A lingering hate from the Civil War got caught up in the turmoil. Some mountain people had supported the Union, others the Confederacy. It had divided neighbors, even families. Some citizens took advantage of the intensified revenuer and army war on illegal whiskey making. They would report the person or family they despised to the federal authorities, accusing them of making whiskey, and sure enough, the revenuers and the army would arrest them and take them in for questioning.

Eventually, the army was suckered into a situation where they arrested and abused a sizeable number of innocent people. In 1879, an act of Congress prohibited the use of troops to aid civilian authorities in making arrests. The revenuers continued their work, but with much less intensity, and the great "Moonshine War" ended.

During the period from 1880 to 1919, there developed an amazing mountain institution, a rather highly respected, illegal industry. Many known moonshiners were involved in politics, leaders in their communities, and officers in their churches. The revenuers were their opponents, but not their bitter enemies. In one story, a revenuer, catching a moonshiner, was reported to have apologized to the man and his family, and the family's reply was "You're just doin' your job. We understand."

Trade in corn whiskey was not totally hidden either. An advertisement in Gainesville's newspaper, the *Eagle*, in June 1900 stated, "Pure old corn whiskey for family and medicinal uses, at $1.50 per gallon, boxed in plain wooden boxes and shipped as merchandise, so no one will know contents of package." Apparently, this kind of trade was okay with local authorities so long as it was for "family and medicinal uses," but practically nobody wanted their fellow church members to know what was going on.

Many local enterprises, mostly located in Gainesville, found good business among the Moonshiners—all very legal, even though they knew full well what their customers were doing. Grocery wholesalers sold them sugar and Mason jars. Automobile dealers sold the "day trippers" cars and parts, with a preference for 1939 Ford club coupes. Banks made them loans. One Gainesville banker said if a man was caught, he or his family would come by and tell him. The bank would extend the loan, adding interest, until he got out. Whereupon the moonshiner would come back, get a loan to get started again, and eventually pay off both loans. One banker commented that he "never lost money on a Moonshiner that made GOOD whiskey." Of course, local lawyers made their money, for Gainesville is the location of the Northeast Georgia Federal Court.

In the early part of the twentieth century, there was a strong movement to outlaw all alcoholic beverages. At the national level, it was led by the Methodists, who even bought (and still own) a building on Capitol Hill, in Washington, to lead the effort for a Prohibition Amendment to the U.S. Constitution.

Locally, any time a referendum came up to legalize liquor sales, the fight against it was usually led by the Baptists with strong support from the Methodists. Many Southern church leaders accused the Presbyterians and Episcopalians of dragging their feet on the issue. The Presbyterians, of Scottish background, were accused of thinking that whiskey making was an honorable profession. The Episcopalians, under the influence of the Church of England, were accused by local clergy of thinking that drinking whiskey was noble. To some degree, this is reported tongue-in-cheek. But this is the type of back-room conversation that accompanied the "Unholy, Holy Alliance." The moonshiners found their most profitable markets in "dry" counties and cities. So, they always found ways

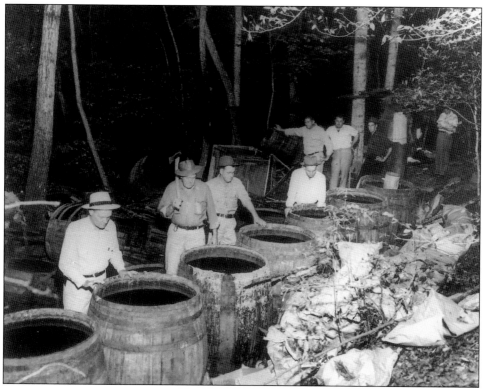

Federal agents and members of the Hall County Sheriff's Department prepare to destroy a newly discovered still in 1950.

to finance the preachers' campaigns against legalized alcohol, and it was this inadvertent and unadmitted combination that was referred to as the "Unholy, Holy Alliance."

The 18th Amendment to the U.S. Constitution, which prohibited the manufacture and sale of what was once called "spiritous liquors" in America, became law in 1919. It was a gold mine for moonshiners. Legal distilleries were closed. Those who knew the illegal system filled the gap. How much money flowed through the mountains from 1919 to 1933? No one can truly know, but tradition says it was a major industry. Then, in 1933, the 21st Amendment nullified the 18th, and Prohibition ended.

However, moonshining continued, and probably continues today. But two things destroyed it as a going industry in Northeast Georgia. The first was a group of moonshiners, said to have been led by one "Fats" Hardy, who distilled their brew through automobile radiators and the resultant lead poisoning killed more than 50 people at one well-publicized party in Atlanta. The second was the advent of cheaper tax-paid whiskey. These two things, old timers say, did more to wipe out the moonshine whiskey business than all the revenuers that ever operated in the rugged mountains of Northeast Georgia.

How big was the moonshine industry? It was sizeable in the late 1800s, huge during the depression, and has tailed off steadily since the 1930s. The U.S. Treasury Department's Bureau of Alcohol, Tobacco, and Firearms (ATF) has estimated 90 percent of America's illicit whiskey was made in the Appalachian/Blue Ridge mountain area—from Pennsylvania through Virginia and West Virginia, North Carolina and across the mountains into Tennessee and Kentucky, and finally into Georgia and Alabama. The art was not practiced throughout the territory; it centered in certain "pockets." But Georgia always reigned supreme as the moonshine-producing champion, usually followed by Alabama. North Carolina did pretty well, too.

But how big was it, really? There are some indications. It was in 1876 that the government estimated that it was losing $500,000 annually in federal taxes. That was not the value of the product; that was just the amount of taxes. And that was at a time when land in North Georgia went for one to two dollars an acre. In the prohibition year of 1925 alone, at the height of the "Noble Experiment,"

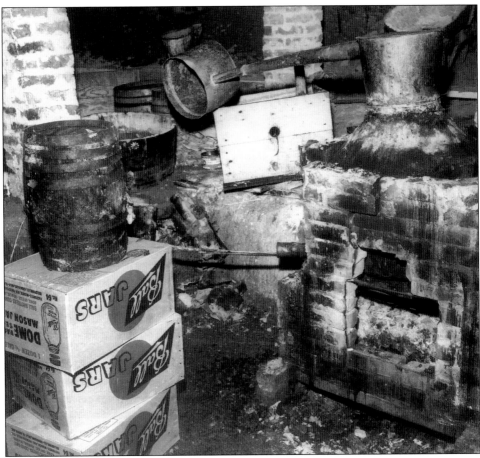

This indoor moonshine still was discovered in the basement of a house in Gainesville in 1950.

federal agents arrested more than 76,000 people caught making and distributing moonshine whiskey. Probably more telling, they seized over 29,087 stills. Although illegal whiskey making fanned out across America during Prohibition, volume production still centered in the mountains of the South.

As late as 1972, ATF agents arrested 3,191 people, destroyed 2,090 illicit distilleries, poured out almost 1,250,000 gallons of fermented mash, and 67,000 gallons of untaxed white whiskey. Joe Dabney, in his book *Mountain Spirits*, writes, "During the year 1972, according to estimates prepared by the Licensed Beverage Industries, Inc. [LBI], America's illicit distilleries turned out more than nine-million gallons of white whiskey. This illegal whiskey, the LBI says, defrauded the federal treasury of $97 million (at the federal tax rate of $10.50 per gallon) and cheated state and community coffers of an additional $35-million."[4] Again, this was not the size of the entire industry Dabney was talking about; it was only the taxes the government missed. And this was in 1972, when most observers were convinced the moonshine industry was "about gone."

By the 1970s, most of the mountain folks agreed that the moonshine whiskey business had lost its luster, and wasn't what it used to be. Prior to Prohibition, it was an honorable profession run by respected professionals, even if it was illegal. During and after Prohibition, it fell into the hands of "some awfully shady characters." It just wasn't the same.

There is a spinoff from the moonshine industry that may develop to be bigger than whiskey making, whatever size it grew to be, and that is stockcar racing. The people of present-day Northeast Georgia tend to think of Bill Elliott, of NASCAR fame, as their foremost star in stockcar racing—and in recent times that is true. But back in the 1940s and 1950s , when Southern stockcar racing was new and neither well reported nor well respected, Dawson County turned out a series of winning racecar drivers. Most, if not all of them, were said to have learned their trade on the crooked mountain roads of Northeast Georgia while delivering moonshine whiskey. For instance, Bill Elliott was not the first person from Dawson County to win the famed Daytona stockcar race. Actually, he was number six, and Dawson County drivers have won the Daytona at least ten times. There were people like Gober Sosebee, who won the Daytona race three times, and would have won it a fourth had he not been disqualified. And Loyd Seay, who died at 21, not from a car wreck, but from an argument over sugar for the family's "still." Roy Hall drove to victory, as did Bernard G. Long, and there was Carleen Rouse, a lady from Dawson County, and a story unto herself.

Fans of stockcar racing have little use for the more classical car races, where the victor is usually determined by who has the best engineered racing machine. In stockcar races, the cars must be made for the streets, and there are strict limitations on how the car and its engine can be modified. In stockcar racing, the race is between daring drivers and skilled mechanics—the same way it was in the mountains of Northeast Georgia when the race was between a daytripper and a deputy sheriff. At this juncture, it appears stockcar racing may gain what moonshine whiskey never did: national respectability.

15. The Rooster Crows:
A New Dawning for Farmers

America's agricultural leaders during the first half of the twentieth century felt chicken farming would never develop as a specialized industry unto itself. There was good reason for this. Farm chickens belonged to the farmer's wife. Everybody understood the "egg money" was hers. Farm experts reckoned you could not compete with a system in which the labor was free, the feed came from the corn crib, and the farm wife was counting on the whole thing for her spending money. Eggs would be the primary product, and frying chicken would be that memorable meal served at special times, like when the preacher came to dinner. America's "egg basket" was in the loamy, rich farmland of the Midwest where row crops provided the primary income. Chickens, the experts reasoned, would always be a farm sideline.

But what these experts failed to reckon with was some lean and hungry farmers in sections of America where the land was poor and not recognized as a leading row-crop area. Those farmers needed a new source of income.

Northeast Georgia farmers had found they could make some pretty good money from "spring fryers" as early as 1880, when the railroad first came through the area. A special railroad car, actually a flatcar with chicken coops built on each side and a walkway down the middle, would park at the railroad station. Farmers would put a bunch of fryers in a cotton basket, throw the basket in the back of the wagon, and bring them to town on Saturdays.

A buyer would be stationed at the car who would weigh the chickens, put them in the railroad coops, and issue script that could be spent at a designated store uptown. This system grew until selling chickens for meat became real farm income, not merely a bonus from egg production.

Thus, the transition began from farm chickens to chicken farming, and as it did, farmers found the need to buy chicken feed from the local store. It was the farm wife who bought into this transition, and the reason was a very simple promotional effort on the part of major feed companies. They sold chicken

A downtown monument in Gainesville declares Gainesville to be the "Poultry Capital of the World."

feed in 100-pound bags, and these companies started bagging the feed in pretty, usable cloth—gingham and flowered designs for the women, plaids for men's shirts. Farm women prided themselves in their ability to sew and make their own clothes, and no women, anywhere, had seen such a treasure trove of cloth since the British first imported silk from the Orient.

As the fertility of the foothills and mountain farmland became depleted, and after the boll weevil began to take its toll in the 1930s, chickens became a solid part of Northeast Georgia farming. One mountain farmer reported his transition this way: in the late 1930s he got three bales of cotton off of 10 acres after spending $140 for fertilizer. That year, he grossed $407. Then, he built houses that would hold 3,000 chickens, and was able to turn out three batches a year. In 1940, he not only sold chickens, but also produced seven bales of cotton, 300 bushels of corn, hay, and feed, and spent $75 for fertilizer. His gross that year was $2,350. Not only that, with chickens, he got a "payday" three times a year instead of only once, as he did with cotton.

In the late 1930s, one could buy a new car for $600 and a lot of chicken farmers did exactly that. It didn't take long before word got around that good money could be made growing frying chickens, or broilers as they were now being called. A front-page story in the *Gainesville Eagle*, just prior to World War II, started this way: "The fuzzy down of the baby chick has all but ousted the fleecy lock of the cotton boll from its pedestal as chief money crop of Hall County." Frying

129

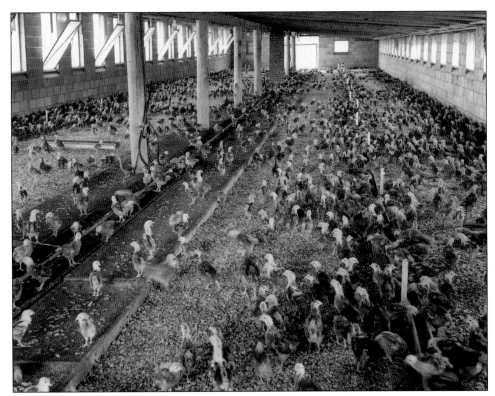

By 1950, broilers could be found in houses like this all over Northeast Georgia.

chickens were expected to bring in a cash income of $750,000 that year, compared with $745,000 from cotton. The cotton income included a significant amount of New Deal government subsidy and conservation payments; the chicken income did not have government support.

There was a limiting factor as to how fast the chicken business could grow, however, and that limit was investment money. Banks were hesitant to loan money on chickens. It was a new enterprise, looked on as risky, and anyway, the banker could never identify the chickens he had made the loan on; they all looked alike.

The idea of an organized broiler industry did not originate in Georgia. The Delmarva Peninsula (the peninsula that includes parts of Delaware, Maryland, and Virginia) was the dominant broiler-producing area at the beginning of World War II, much larger than Georgia. But Georgia was a factor, and a sizeable number of feed dealers and farmers were active in the business, almost all of them located in the low-mountain area of the state, especially Hall, Forsyth, and Cherokee Counties. Yet, the thing that changed the chicken business from a relatively small farm income producer into a major agricultural industry was a new business structure which came to be called "vertical integration," and the person credited with making it work was Jesse Dixon Jewell.

Jesse Jewell's mother had a failing feed store in Gainesville, and in the midst of the depression, he had dropped out of Georgia Tech to come home and try to revive it. A 1954 promotional brochure from J.D. Jewell, Inc. described the evolution as follows:

> he found himself in the awkward situation of running a feed business in a community that had very few chickens, and those who had chickens had no money to pay for feed.
>
> Then commenced the Bootstrap Operation that was the key to his success. He gave one-day-old chicks to farmers in the area, with a retention slip on the chicks. He then gave them feed on credit to raise the chicks. When the chicks were full grown broilers, he picked them up from the farmers, packed them on an old Reo truck which he drove to Miami, Florida, himself and sold the chickens.

In the more prosperous farming areas of America where farmers proudly "stood on their own," this would have been looked down on as "sharecropper farming" and would have been socially unacceptable. But this type of working relationship between farmer and businessman was not unusual in the South, and especially in poor farming areas like Northeast Georgia. Feed and seed stores routinely furnished their farm customers with seed and fertilizer, and often some

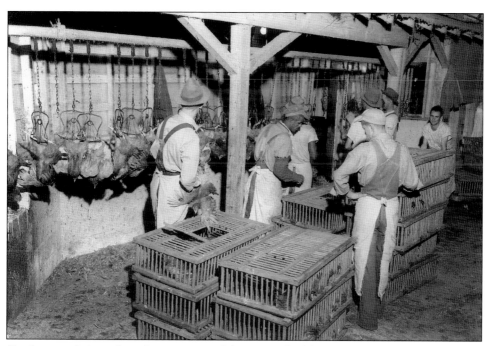

Broilers are being taken from coops and hung on shackles at Martin Poultry Company processing plant in 1947.

money for groceries, until the crop came in. For Northeast Georgia's destitute small farmers this looked like a good deal. They were beyond worrying about what was "socially acceptable."

If the Jewell leadership had stopped there, it would have been a major step. But it didn't. There weren't any local hatcheries, and when he had a hard time getting chicks shipped in, he started a hatchery. He built a poultry processing plant, and proudly started selling "dressed" broilers to major chainstores. Jewell started a rendering plant to make feed ingredients from the by-products of the processing plant. There was a research farm where the company developed more efficient ways to produce broilers. They even attempted to package and sell poultry manure as high-grade plant food, but that did not work out too well. Eventually, the company built its own feed mill, a difficult step since it not only had to replace the supply of feed, but it also had to replace the major source of feed-company financing. The only thing he did not bring in-house was the growing of the broilers. Holding true to his company beginnings, Jewell contracted with independent farmers to do that job. Jesse Jewell integrated the business, putting it all under one corporate roof.

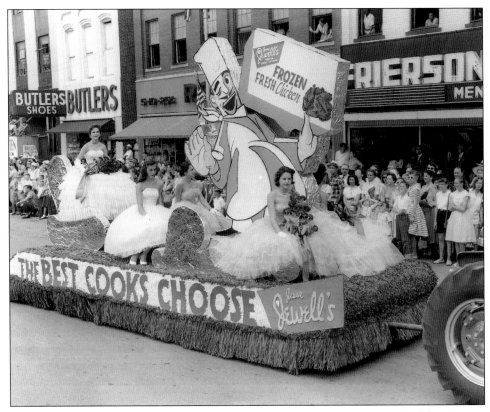

The Jesse Jewell Frozen Fresh Chicken float motors by in the opening parade of the Georgia Poultry Festival in downtown Gainesville, c. 1955.

Independent hatcheries, like this one at Chestnut Mountain, sprung up throughout the area.

The book *The Agribusiness Poultry Industry* told the story this way:

> many people literally felt it was "wrong" to get into all phases of the business. After all, in the traditional U.S. poultry areas a hatcheryman had to have his profit, and a feed dealer had to have his profit, and the feed mill had to have its profit, and the grower had to have his profit, and the marketer had to have his profit—and Jesse Jewell was putting them all under one roof where he needed only one profit. And his profit could naturally be smaller than that needed when all the segments were separate.
>
> This was one of the great efficiencies which brought on the charges (especially from poultrymen in the North and Midwest) that the Southern areas were willing to produce and sell for less than other areas—and it was probably a valid observation. The people of the South, however, felt they were making a reasonable amount of money, and plowed ahead.
>
> Some of the observers of the industry feel the truly amazing part of the Jewell story is that he brought together enough capital to build an integrated structure in a time when capital was scarce, the chicken business suspect, and profits erratic.[1]

Jesse Jewell was not the only person, of course, who built the poultry industry in the mountains of Northeast Georgia. There were many, but almost all would agree that he was the optimistic, enthusiastic innovator who became the industry's leading entrepreneur and spokesman in its early days.

Chick-n-que at City Park in Gainesville is part of the Georgia Poultry Festival. Early poultrymen promoted their industry with gusto.

Arthur Gannon, the veteran University of Georgia Extension Poultryman, wrote a piece on the industry in the *Georgia Review* in the fall of 1952. "Why North Georgia?" he asked, and then answered as follows:

> The North Georgia broiler section includes thirty counties, and takes in the Northern part of the Piedmont and most of the mountain areas of the state. In the mountains and foothills the nights are usually cool, even in midsummer, which is an advantage in growing chickens. The farms are small, and the tillable land is limited. Cotton was the main cash crop, and with only small acreages, farmers had difficulty in making a living. Many of the natives are of pure Anglo-Saxon stock—proud, hard-working, honest folk. The homes were unpainted and dilapidated and the farms run down.
>
> This economic set-up made an ideal situation for broiler growing. Beginning as a sideline farm enterprise, it soon developed into the main source of income. Broilers provided cash the year around, while in the case of cotton, money came in only once a year, when the cotton crop was sold in the fall.
>
> The broiler industry raised the standard of living on the farms. It supplied the means for farmers to remodel their homes, to buy water

pumps, washing machines, electric ranges, and radios. During the past two years television aerials have blossomed on the roofs of practically every home. New consolidated schools and new churches were erected in many communities. What a difference in 15 years.

. . . Broiler growing has also helped the nearby towns. It is a well-known axiom that prosperity of the farmer means prosperity of the businessman.[2]

Although Jesse Jewell is generally recognized as the pioneer who gave the broiler industry its structure, it was the national feed mills that promoted its rapid growth just after World War II, and they did it primarily by offering credit to their feed dealers. Most of the national feed mills, and several of the regionals, had ready access to the large money markets, and because the broiler industry offered the most promising new market for feed ever, the feed companies turned their biggest sales guns on this market.

A quirk in the business, however, made considerably more money available for each feed dealer than was intended, or necessary. It was traditional in agriculture at that time to make loans to cover the period required to produce a crop. So the

A young but already famous Johnny Carson helps crown Georgia's poultry queen in 1959. Carson hosted the Tonight Show *on television for several decades.*

Huge gullies had developed on hillside cotton fields, and many fields had been abandoned. Litter, a by-product of the poultry industry, helped grow pastures and pine trees, which rebuilt the land.

feed mills figured it this way: we will let the dealer finance the baby chicks and then give him a line of trade credit to cover the feed until the flock is sold. They figured a 90-day trade acceptance ought to be fair.

It was a bonanza for the feed dealer. The quirk came because in traditional row-crop agriculture the farmer needed all the credit up front, for seed and fertilizer. Chicks took 10 weeks to grow out, but they took very little feed the first few weeks. Once a feed dealer got it rolling, he had much more credit than he really needed . . . even much more cash so long as broiler prices stayed high.

His first reaction was to go get some more growers, which increased the credit line still more. Reaction two: buy a big, new car. There was a time in the 1950s when the area including Gainesville, Cumming, and Canton, Georgia, was said to have more Cadillacs and Lincolns per capita than any other area in the South—Texas included.

With the appearance that some people were getting rich in the broiler business, a gold fever mentality began to develop. Everybody "wanted in." Years later, it was reported that a feed dealer financed a hatchery by selling one-third of it to a doctor, but it turned out the doctor was the only one who put any cash in the venture. The doctor made pretty good money anyway.

It was about this time, too, that the larger business world was experimenting with equipment leases and lease-purchase arrangements. There was a management theory developing which said there was no glory in owning capital goods; it was the use of the capital goods that counted. So poultrymen leased trucks, buildings, equipment, and the poultry industry extended its capital to incredible lengths compared with other businesses. As was pointed out in *The Agribusiness Poultry Industry*, "No matter where the money came from, no matter how flamboyant some of the financial practices may have been, the commercial broiler industry was built on the profits it generated—and they were sizeable."[3]

When broiler prices were high, the industry made money—big money. But by the 1960s, poultrymen learned the markets could go down, too. And when they did, the entire financing procedure reversed and disaster struck hard and fast. The maturing process began.

But an industry had been built by then. Critical mass had been reached. Georgia had become the number-one broiler-producing area in America. The industry had processing plants, hatcheries, and feed mills in practically every town in Northeast Georgia. Literally thousands of mountain farmers were able to remain on their beloved land and still make an above-average living. The economic benefits of the poultry industry have permeated all of Northeast Georgia. An executive of the Grange Company, from Upstate New York, whose hobby was the history of agricultural trends, said, "The development of the broiler business was the greatest transfer of soil fertility in the history of North America."[4]

In the 1940s, when the broiler business began developing in Northeast Georgia, the rolling hills and low mountains were a raw, red sore. The forests had been cut over. The red clay fields were lying fallow and eroded, unable to make a reasonable crop of cotton. What nutrients had not been used up in one-crop agriculture had leached out, or eroded away to the streams. The Chattahoochee River ran muddy-red all year long, to the point Hall County Agent Leland Rew said it was "too thin to cultivate and too thick to navigate." From a farming standpoint, Northeast Georgia was a desolate land "B.C."—before chickens.

During 50 years of poultry farming, millions-upon-millions of trainloads of feed grains have been brought in from the Midwest, carrying nutrients drawn from the deep, rich soils of the Mississippi Valley, the Ohio, and the Missouri— the breadbasket states. This feed has fattened the chickens, and then the poultry litter, rich in nitrogen and other nutrients, has been placed on the worn-out soil of Northeast Georgia. The mountains, repaired and rebuilt, are now covered with green pastures and tall trees—richer now than when the first settlers cleared land to plant their meager crops.

16. The Islands Join the Highlands

Large lakes are not part of the natural geography in the Blue Ridge Mountains of Northeast Georgia. There were always fast-flowing streams and tumbling waterfalls, but few places where water slowed down long enough to pool, let alone form a lake. As poet Sidney Lanier said in his famous "Song of the Chattahoochee:"

> Out of the hills of Habersham,
> Down the valleys of Hall,
> I hurry amain to reach the plain,
> Run the rapid and leap the fall . . .

Waterpower was harnessed early in the settling and development of Northeast Georgia for gristmills, and it was not lost on early civil engineers, especially in the early days of electric power generation, that North Georgia rivers often traversed narrow valleys with high, steep banks. These mountains were ideal for building dams to impound water.

During the early days of the twentieth century, from 1900 to about 1920, a series of dams was built in Georgia to generate electricity. The Chattahoochee River was dammed up near Gainesville, furnishing electricity to Gainesville residents and its street railway system. Other local power plants were built. But the first major power plants, intended to transfer electricity over long distances, were built along the waterways of the Northeast Georgia mountains by the company that evolved into the Georgia Power Company.

Lake Burton, with 2,775 acres and 62 miles of shoreline, and Lake Rabun, with 835 acres and 25 miles of shoreline, became the best known of the Georgia Power lakes, but a string of smaller lakes were also developed. Lake Seed, Tallulah Falls Lake, Lake Tugalo, and Lake Yonah, near Toccoa, all became recreational lakes as well as power producers.

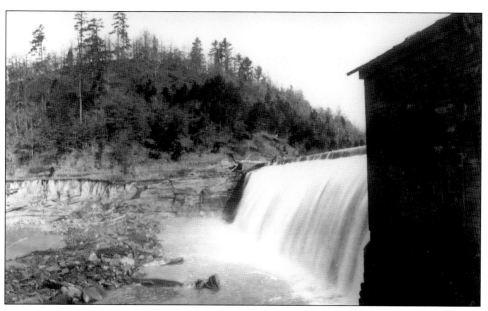

Seen here in 1914, the dam at Dunlap Shoals, near Gainesville, was the Georgia Railway and Power Company's plant on the Chattahoochee River.

It was the Georgia Power lakes, more than any other, that set the stage for resort and recreational development that included lakes as well as mountains, and were responsible for creating the highlands and islands area of Georgia.

The Tennessee Valley Authority (TVA) was first proposed through an act passed by Congress in 1922, but it was in 1933, only a few weeks after taking office, that President Franklin Roosevelt proposed a new kind of federal agency charged with "the broadest duty of planning for the proper use, conservation and development of the natural resources of the Tennessee River drainage basin." It was from this beginning that three TVA lakes ended up in Georgia's mountains, a fountainhead for the rivers that fed into the Tennessee River. Lake Blue Ridge, which has 3,200 acres, and is located near Blue Ridge, Georgia, was acquired by the TVA in the early 1930s.

In 1941, North Georgia newspapers reported that the TVA "faced with a serious shortage of electric power for defense industries in the southeast, has requested $51,000,000 for the construction of four new dams." Two of those dams would back water up in Georgia. Nottely Lake, located near Blairsville, Georgia, was to be entirely in Georgia, and not far from Murphy, North Carolina. Nottely Dam, and the dam for Lake Chatuge, were built in 1941–42. Lake Chatuge, a 7,000-acre lake about half in Georgia and with the rest in North Carolina, backed water into the city limits of Hiawassee, Georgia. This dam was located on the Hiawassee River, which begins on the northwestern slope of the Blue Ridge Mountains in northern Georgia at elevations of 2,500 to 4,500 feet above sea level, and empties into the Tennessee River about 35 miles upstream from Chattanooga.

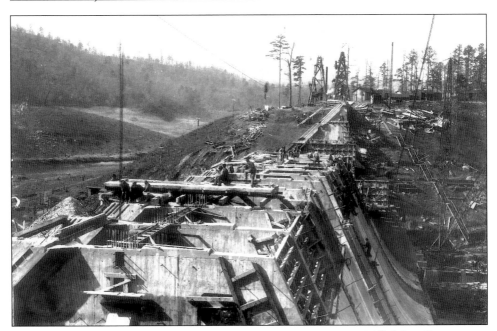

In this 1914 view, the Mathis Dam is seen under construction near Tallulah Falls.

There was great concern among local citizens when the dams were built. Some of the best farming land in the area was taken out of production. And other citizens were concerned that the loss of land from the tax digest would cause a tax increase for the remaining citizens. The TVA developed a system for making annual payments to counties "in lieu of taxes," insisting those payments were always more than would have been received in taxes from local landowners.

So it was that Georgia got a string of lakes, right across the top of the state and threaded among its highest mountains—from the Georgia Power lakes that sent their water to the Atlantic Ocean, to the TVA lakes whose rivers sent their water eventually to the Gulf of Mexico at New Orleans.

Then, in the River and Harbor Act of 1945, Congress authorized a comprehensive development for the Alabama-Coosa River system, and Carters Dam and Lake were designed for the Coosawattee River, near Ellijay. This Corps of Engineers lake was effectively designed for power production and flood-control reasons, especially for Rome, Georgia, which had a history of flooding.

But what about the Chattahoochee River that came off the south side of the Blue Ridge Mountains? That was the water that caused floods in Gainesville and Atlanta, and eventually poured into the Gulf of Mexico.

The federal government had developed programs for America's rivers beginning in 1874, when the first River and Harbor Act was passed. For the most part, this act was aimed at improving harbors and keeping coastal rivers navigable, but little by little, other reasons for river projects were added to navigation: flood control, hydro power, water regulation, and, finally, recreation.

The Chattahoochee River first appeared in the national rivers program in 1915, when "a preliminary examination and survey" was authorized. During the 1930s, the Corps of Engineers did initial investigations about the possibility of a dam on the Chattahoochee, near Atlanta.

Federal work on inland rivers went dormant during World War II, but at the end of the war, Congress returned to its emphasis on rivers and harbors with budgets, as described at the time, "that would far exceed any legislation attempted to date." Monumental legislation was signed by President Harry Truman that triggered a $600-million, 10-year nationwide program. It was promoted to the American taxpayer on two major counts: first, World War II had shown the need for more electricity for defense, and second, for flood control.

The Chattahoochee was a likely prospect for flood-control work. Heavy rains in the mountains, especially in late winter and early spring, often brought devastating flash floods down on Atlanta, West Point, Columbus, and other towns along the river. There were newspaper reports of a "great flood" as far back as 1886. In 1947, Brown's Bridge, near Gainesville, was washed away by a flood that reached 26 feet above the Chattahoochee's normal level. A couple of years later, a mountain flash flood caused the river to rise more than 20 feet overnight at Dawsonville Bridge, just outside Gainesville.

It was not hard to prove that the Chattahoochee River, fed by a massive watershed that cascaded down from the mountains of Northeast Georgia, was an excellent candidate for a flood-control program and a major dam. Add to this logic the fact that there was considerable "politickin' goin' on," led by the visionary

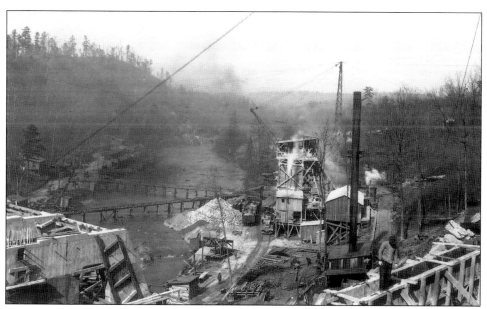

Deep ravines and fast-flowing rivers made ideal spots for mountain lakes and power plants, as this scene in Rabun County in 1914 illustrates.

141

Mayor William B. Hartsfield, of Atlanta, Senator Richard Russell, and a trainload of others, and the Atlanta area got its approval in 1947 for a multi-purpose federal dam primarily for flood control, navigation, and power production. Also, promoting the idea of river-barge transportation all the way from the Gulf of Mexico to Atlanta, making the Chattahoochee a navigable waterway, helped in Washington since navigable rivers carried more clout than non-navigable. For some promoters of the idea, Atlanta as a port city was actually a major goal, not a political ploy, which led one South Georgia editor to express this opinion: "If Atlantans could suck as hard as they can blow, the ocean would already be there and they wouldn't need a dam." Not all Georgians loved Atlanta.

Many sites for a dam on the Chattahoochee River near Atlanta were considered by the Corps of Engineers, just as many narrow crossings were considered for a railroad bridge to cross the Chattahoochee in the 1830s. The first site studied was near Roswell. The fact land in that location would be more expensive was not a major deterrent, but the fact it would require significant road and railroad relocation was. Surveying began farther north, and there, near Buford, the Corps of Engineers found what Robert David Coughlin, in his book *Lake Sidney Lanier*, called "A Storybook Site."[1]

Ground was broken for Buford Dam in 1950, and the floodgates were closed on February 1, 1956. Lake Lanier first reached full pool in 1959. Lake Lanier, at its normal pool elevation of 1,071 feet above sea level, encompasses 38,000 acres and has 540 miles of shoreline. The government acquired more than 56,000 acres of private land to accommodate the entire project. It has 48 federal parks, several

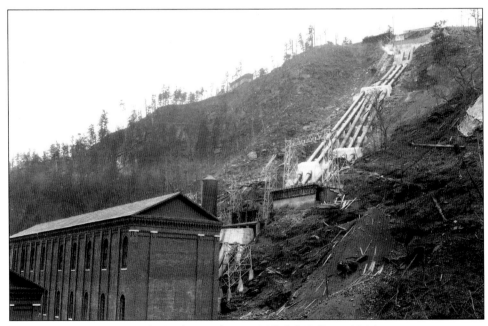

This is an early mountain hydroelectric plant in Tallulah Falls in 1914.

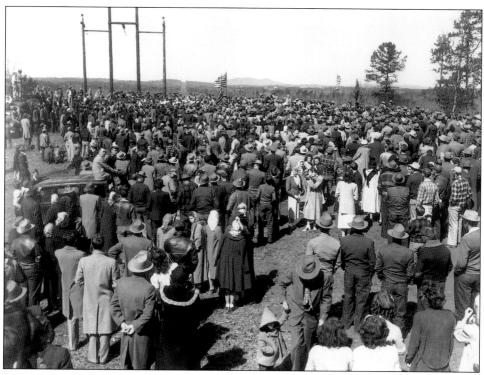

Several thousand people turned out for the dedication of Buford Dam.

county and city parks, and seven commercial marinas. Located just 35 miles from Atlanta, it has become the most visited Corps of Engineers lake in the United States. In 1995, recreation was estimated to be a $2-billion business on Lake Lanier, a year in which almost 7 million people visited. By the year 2001, the lake had more than 20 million visitors. About 3 million people get their drinking water from that body of water. As growth has come, the water and the land has become more precious. Lake Lanier is a reality, but who gets to use the water from the Chattahoochee may be an unsettled issue. As Joe Cook noted in his book *River Song*, "In 1990, quarrels over the allocation of river water came to a head when the states of Alabama and Florida filed a lawsuit against Georgia to prevent Metro Atlanta's suburbs from increasing their withdrawals from the river."[2]

It was not the first time there had been disagreement about the river. Many people in Northeast Georgia had opposed the Buford Dam during the planning stages because it would flood the best farming land and some of the most historic homesteads in the area (some insisted it was the richest farming land in all of Georgia). Agriculture was the economic engine that drove Hall County, and the Chattahoochee bottom land provided the majority of land for row-crop farming. Not only that, but the city of Gainesville had lost many of its most historic homes and buildings in the tornado of 1936, and many were not pleased with the idea of losing their rural history as well.

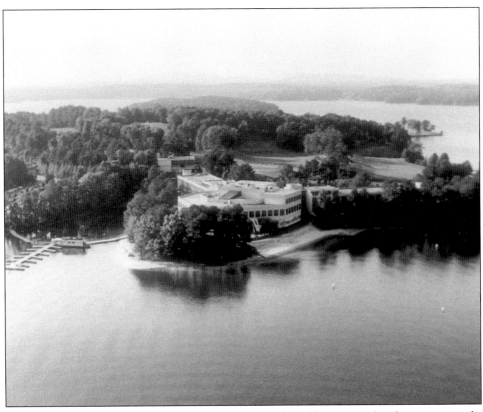

Lake Lanier Islands Resort was developed with hotels, golf courses, a beach, a water park, and other recreational facilities.

It was an emotional time; a time some longtime natives likened to the Trail of Tears. After all, 700 families were uprooted—feeling fortunate to get $50 per acre for their land. Much of it had been in the same family for several generations. Some 50 cemeteries, with more than 1,000 graves, were dug up and moved to new locations. The coming of Lake Lanier was neither pleasant nor easy for a lot of Northeast Georgians.

It took a while for the economic immensity of this event to sink in. But at the end of 50 years, it is obvious the building of Buford Dam and the coming of Lake Lanier have changed the character of Northeast Georgia. Lake Lanier became a magnet drawing Atlanta northward, and at the same time, an anchor outlining the southern border of Georgia's mountains, just as the earlier lakes had defined the northern border.

The mountains had always been here, of course. But with the coming of the manmade lakes, the Highlands and Islands region of Georgia was defined: a mountain hideaway for all the Deep South—an immediately available, inland playground for the growing Atlanta to Charlotte megalopolis and a beautiful and relaxed retirement area for people from everywhere.

17. New Highways: The Floodgates Open

History shows that trade goes where transportation allows it to go. That is why most of the major cities of the world are seaport cities. Georgia initially developed along the coast, first at seaport towns and then along navigable rivers. Shipping goods by water was easy and inexpensive.

Even in Georgia's piedmont area, above the fall line but below the mountains, roads could be built inexpensively, on relatively flat land. This came to light forcefully with the building of the railroads in the 1800s. The early railroads sought the most efficient, least expensive routes. They dodged the mountains. Atlanta became a trade center because it had become a railroad hub.

Georgia's highways were another matter. The roads and highways tended to follow the old Indian trails. Those were the routes followed by the first settlers. It was along these roads that the towns were built, and trade patterns established. To change the basic route of a highway caused much anguish, so very few highway routes were changed in Georgia until after World War II. Roads were paved and improved beginning about 1900. The worst curves were straightened, but the routes they traveled remained basically the same.

Road paving in Georgia, as in most states, focused first on city roads and then on major, connecting highways—that is, connecting major trade cities. Gainesville had become the trade center of the mountains because of the mountain railroads that fed into that town, and road improvement and paving tended to follow the same pattern. To some degree, it was this road improvement pattern that led to the decline of the mountain railroads as trucks began to haul freight more efficiently. But compared to the rest of Georgia, road development in the mountainous area of Northeast Georgia came slowly. Very slowly.

Perhaps the best way to describe the history of mountain roads is by using some of the stories that have been told. John Muir, the renowned naturalist on

his Thousand Mile Walk to the Gulf in 1867, describes some Georgians on a road near Yonah Mountain, in White County as follows:

> Traveled in the wake of three poor but merry mountaineers—an old woman, a young woman and a young man—who sat, leaned, and lay in the box of a shackly wagon that seemed to be held together by spiritualism, and was kept in agitation by a very large and a very small mule. In going down hill, the looseness of the harness and the joints of the wagon allowed the mules to back nearly out of sight beneath the box, and the three who occupied it were slid against the front boards in a heap over the mules' ears. Before they could unravel their limbs from this unmannerly and impolite disorder, a new ridge in the road frequently tilted them with a swish and a bump against the back boards in a mixing that was still more grotesque.
>
> I expected to see man, women and mules mingled in a piebald ruin at the bottom of some rocky hollow, but they seemed to have confidence in the back board and the front board of the wagon box. So they continued to slide comfortably up and down, from end to end, in slippery obedience to the law of gravitation, as the grades demanded. ... The old lady, through all the vicissitudes of the transportation, held a bouquet of French Marigolds.[1]

As late as the 1930s, people traveling by car from Hiawassee or Blairsville to Gainesville took a sharp axe and a piece of strong rope with them. When they reached the top of the mountain, they stopped before starting down, and cut

Early mountain roads often started as Indian trails, then became packhorse paths, and eventually were widened to accommodate wagons or buggies.

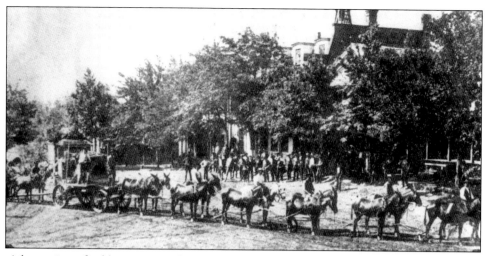

A large piece of gold-mining machinery, weighing 9 tons, is hauled by these mules from the railroad in Gainesville to Dahlonega c. 1899.

a large limb or a sapling. This they tied on the back of their car as a braking mechanism. Otherwise, the brakes would burn out before they reached the bottom of the mountain. When they reached flat land, they cut the sapling loose and threw it over the side of the road. The point where roads topped mountains was usually bald, for the trees there had been cut for use as brakes since wagon days.

Some of the largest wagons ever to operate in Northeast Georgia were said to be those that carried gold-mining equipment from the railroad in Gainesville to Dahlonega. Remembering these conveyances as huge and heavy, old-timers say these wagons were "built like a bridge." The wheels had very wide, steel tires to keep them from sinking into the road. They were pulled by as many as 12 horses in front, and pushed by 4 horses in the back. Very little equipment of this size, it was said, was delivered to towns off a major railroad.

Some of the roads between major towns in Northeast Georgia were not paved at the beginning of World War II, and practically no farm-to-market roads were paved at that time.

One of the problems with state-supported roads came because the legislature and the State Highway Department tended to allocate road money evenly by districts. The old county unit system of representation that held forth in the 1930s gave great power to the rural areas of South Georgia, and they could use their money to build many more miles of road in flat country than Northeast Georgians could in the mountains. Good roads came slowly to Northeast Georgia.

Shortly after World War II, President Dwight Eisenhower proposed a national network of major highways for defense purposes. One of these highways, designated I-85, would travel along the east side of Georgia's mountains,

The tops of mountains, where cars and wagons crossed, were without trees. The trees had been cut for use as brakes on the downhill side, and they also "swept" the road and helped keep it in good order. This road was believed to be located between Cleveland and Dahlonega.

connecting Atlanta and Charlotte. Another, designated I-75, would move along the west side of Georgia's mountains, connecting Atlanta and Chattanooga. For the first time, major highways were not necessarily going to follow the route of existing roads, but would be surveyed along the most direct route from one city to the next.

A great political battle developed over the route of I-85. The counties of the mountains, led by a group from Gainesville, proposed that I-85 should follow the route set by the Air Line railroad in the 1880s, going from Atlanta to Gainesville, to Cornelia, and crossing into South Carolina near Toccoa. The mountain coalition insisted this would serve the most people, and would be a direct route to Greenville.

But when the route for I-85 was officially announced, instead of moving northeast to Gainesville, it veered farther eastward from near Buford, traveled half-way between Gainesville and Athens, and crossed into South Carolina near Lavonia, the hometown of Governor Ernest Vandiver. Politically, all hell broke loose in the mountain trade area, but it did not change the route of I-85.

Four-lane interstate highways were being built all over America, but not in Northeast Georgia. It was less expensive, it was explained, to build highways in the rolling land of the piedmont than in the more mountainous areas. Construction on I-75 and I-85 began about 1950 and both highways were completed in the late 1970s.

It took a second wave of road building to get major highways approved in Northeast Georgia, but they did come. On the east side of the mountains, I-985 was spun off of I-85 beginning in 1962, connecting Atlanta to Gainesville and opening up easy travel to the eastern shores of Lake Lanier. Highway 23 was

improved to four-lane status (although not designated a limited-access highway) to Cornelia, and then improved roads went on north to Clayton, Mountain City, and Dillard. A spur reached Toccoa. On the west, I-575 veered off I-75 eastward near Marietta, connecting to Canton and Ball Ground, before becoming a four-lane to Ellijay. Construction on this highway was started in 1978 and most of it was completed by 1984.

Then, in the middle of the mountain triangle that reaches southward toward Atlanta, Georgia Highway 400 was surveyed up the western shores of Lake Lanier, traversing the area near Cumming, Dawsonville, and Dahlonega. This corridor was started in Atlanta and Forsyth County in the early 1970s and completed in Forsyth County, and into Lumpkin County, near Dahlonega, in the late 1970s. And across the very top of the state, an easily traveled east-west highway, State Route 76, goes from Clayton to Hiawassee, to Young Harris, to Blairsville, to Blue Ridge, and then south to Ellijay. Carved through the mountains in three separate pieces, this connecting highway was started about 1980 and was completed before 1990.

Adding to this network has been a significant improvement in the existing two-lane highways of the region and the development of a little-known group of paved farm-to-market roads. However, there is still no major east-west highway through the mountains, the kind first envisioned when a railroad from Augusta to Chattanooga was proposed in the 1830s. But as the century turned to the year 2000, one was proposed and was being put on the list for activation early in the twenty-first century.

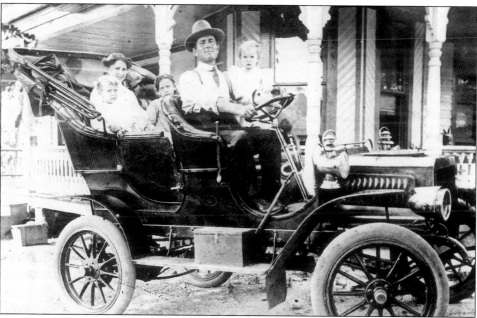

This proud family poses with their new car in Habersham County c. 1915.

18. Recapturing and Preserving the Heritage

The Northeast Georgia trade area, that is the Highlands and Islands region in which the Blue Ridge Mountains are surrounded by a string of large lakes, has developed a distinctive culture all its own. It is in the South, but not of the South. It is a blend of the hardworking, God-fearing small family farmer who first settled this land, and rambunctious, risk-it-all gold diggers who came to find their fortune in the cold, fast-flowing streams. It is a culture in which mountain folk had no use for the plantation system with its slavery, and yet who were some of the most dedicated, most daring soldiers in the Confederate army. It came from fast friendships between wealthy, cosmopolitan summer people who came to the area for health and leisure, and poor, hardscrabble folks who considered it an adventure when they left the farm to go to town.

The history of the area developed a people who were independent and conservative in their philosophy; hardworking; willing to take business risks; and predominantly Protestant Christian in their religious beliefs. They have proven their ability to take hard times and make a comeback, as when they lost the railroad to Atlanta, or when they lost I-85, or when the boll weevil and the chestnut blight destroyed major income producers, or when the economic center of the mountain trade area was totally flattened by a tornado.

Northeast Georgia is an area in which its economy and its people have been molded by mountains and waterfalls, and then by lakes. It is an area with a distinct heritage all its own, different from the traditional South which almost surrounds it. It is unique. Toward the end of the twentieth century, interest heightened about recording and preserving the history and culture of this area. Several of these activities are worthy of special mention.

In the early 1900s, the federal government began acquiring national forest land, and the mountain area of Northeast Georgia was included in this plan for a reserve in the Appalachian Mountains. In the year 2001, the Chattahoochee National Forest owns and maintains more than 750,000 acres of choice mountain

The Georgia Appalachian Trail Club held its 10th annual meeting at Vogel State Park in Union County in 1939.

land in Georgia, some of it the most scenic in the South. It is an area larger than the entire state of Rhode Island, and is set aside exclusively for managed forestry, wildlife and hunting, and recreation. Few other spots in the world have this much undeveloped, scenic mountain land so readily available to large population areas.

The Appalachian National Scenic Trail is a 2,100-mile wilderness footpath that starts at Springer Mountain, in Northeast Georgia, and ends at Mount Katahdin, in Maine, and is considered one of the most amazing natural trails in the civilized world. The Northeast Georgia portion of the trail extends about 75 miles through primitive areas of the Chattahoochee National Forest, generally at elevations between 3,000 and 4,400 feet. The entire trail is maintained by volunteers, and the Georgia portion is managed and maintained by the Georgia Appalachian Trail Club, through a cooperative agreement with the U.S. Forest Service, Chattahoochee National Forest. The approach trail to Springer Mountain can be accessed at Amicalola Falls State Park on Georgia 52.

Foxfire begins with the story of a young English teacher who first faced a class of bored ninth and tenth graders, and his successful search for a way to make school, and especially English, more exciting. He convinced his students that they should go out and interview older relatives and friends in the Rabun Gap area about what mountain life was like "back when." Out of this has come two things: 1. a teaching system that has been adopted by teachers and schools all over America (all over the world, for that matter); 2. 11 nationally popular books published by Doubleday, featuring stories written by high school students,

151

Ed Dodd created the conservation comic strip Mark Trail *and his work is remembered in the Ed Dodd room at the Georgia Mountain History Museum in Gainesville.*

recording the lifestyles and memories of people who settled the high mountains of Northeast Georgia. Some say it is the most extensive collection of folklore about any single section of America.

Ed Dodd was a forester living in Gainesville, Georgia, with a natural talent for cartooning. He was looking for a more effective way to educate people, children and adults alike, about conservation. Out of this grew the comic strip *Mark Trail*, which became nationally syndicated, and for more than 50 years has helped educate millions of Americans about nature and how to take care of it. Though Dodd is now dead, the comic strip and its story of conservation is being carried forward by Gainesville native Jack Elrod. A section of the Georgia Mountain History Museum at Brenau University is dedicated to Ed Dodd memorabilia.

One of the few successful regional magazines in the United States dedicated to history, lifestyles, and travel ideas of a relatively small geographic area, the *North Georgia Journal* was founded in the early 1980s by Farrel Anderson and Jimmy Anderson, the postmaster of Dahlonega, Georgia, as a way to publish and preserve historic stories about the area and its families. In 1987, it was acquired by Olin Jackson, then on the staff at North Georgia College. It gained unexpected acceptance from a wide range of subscribers, and Jackson, with encouragement from Sylvan Meyer and Gordon Sawyer, has built it into a successful commercial venture centered on the history of Northeast Georgia, Northwest Georgia, and

North Atlanta. In addition to a quarterly magazine, the company has published four books, collections of the history articles published in the magazine.

Smithgall Woods is a 5,555-acre mountain woodland originally bought and restored by Charles Smithgall, of Gainesville. He sold it to the State at half its appraised value on the premise that it would be perpetually used for educational and recreational activities and not developed. Operated as a Heritage Preserve, the facility is managed by the Department of Natural Resources to protect the existing landscape, maintain wildlife diversity, offer environmental education, and for low-impact recreational opportunities. It is located in White County, between Cleveland and Helen. Smithgall and his wife, Lessie, have also been generous supporters of major art and cultural projects in Northeast Georgia.

In the development stage during 2001, the 170-year-old Hardman Farm in the Nacoochee Valley features an Italianate country home with surrounding outbuildings. A gift to the state from the Hardman and Randolph families, it is being developed as a "living history center." The most widely known feature of the project is a 130-year-old gazebo that sits atop an Indian mound on bottom land adjacent to the Chattahoochee River, alongside Georgia Highway 75 near Helen. This point is also expected to be the northern anchor for a proposed 200-mile greenway along the Chattahoochee River, going past Atlanta to Columbus.

White Path was a Cherokee chief who died on the Trail of Tears. He was from a deep mountain area near Ellijay, and when it became apparent his old home

The Indian mound is visible here in 1915 in the Nacoochee Valley with a glimpse of the Hardman house in the distance.

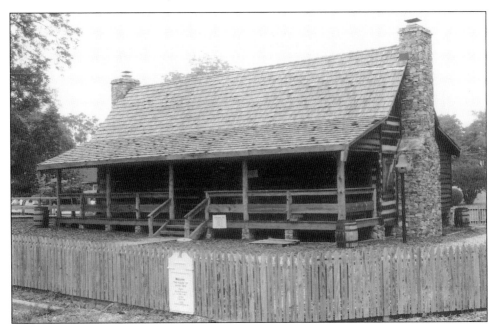

Chief White Path's home is currently located in Gainesville.

would be allowed to deteriorate, descendants moved the old house to Gainesville. There, a retired banker named James Mathis took the cabin on as a personal project and renovated it. Chief White Path's Cabin now is a part of the Georgia Mountain History Museum at Brenau University, and is an excellent historic example of frontier homes about 1800.

As the century turned, activity was intensifying in a large number of historical and cultural organizations in Northeast Georgia: the Quinlan Visual Arts Center, in Gainesville; the Sautee-Nacoochee Community Association, in Sautee-Nacoochee; the Smithgall Arts Center, located in the old railroad station and the old Methodist Church, in Gainesville; and the Dahlonega Courthouse Gold Museum, in Dahlonega. This list of places does not include the many heritage-oriented activities taking place at the colleges or the public libraries. In Dahlonega, a new project called the Folkways Center of the Georgia Mountains was underway, and the old stone schoolhouse in Dawsonville was being proposed as a historical and cultural center. In White County, Union County, and Banks County, the old, historic courthouses have been dedicated as museums, and the Rabun County Historical Society, in Clayton, has acquired use of a historic home adjacent to the courthouse as its headquarters. There are also active history groups in Forsyth County, Habersham County, and Hall County (both in Gainesville and Flowery Branch). And these do not cover the many local genealogical groups.

The Highlands and Islands area of Northeast Georgia is rich in history. As the century turns, it appears there is a growing interest in recapturing and preserving it.

Notes

CHAPTER ONE
1. White, Max E. *Georgia's Indian Heritage*. p. 122.

CHAPTER TWO
1. Robinson, W. Stitt. *The Southern Colonial Frontier 1607–1763*. p. 184.
2. Rouse, Parke, Jr. *The Great Wagon Road*. p. VII.
3. Ibid., p. VII.

CHAPTER THREE
1. Robinson, W. Stitt. *The Southern Colonial Frontier 1607–1763*. p. 67.
2. Turner, Frederick J. *The Frontier in American History*. p. 246.
3. Garrett, Franklin. *Atlanta and Environs: A Chronicle of Its People and Events*. Vol. 1. p. 1.
4. Coleman, Kenneth. *A History of Georgia*. p. 133.
5. Ehle, John. *Trail of Tears: The Rise and Fall of the Cherokee Nation*. p. 390.

CHAPTER FOUR
1. Dahlonega Courthouse Gold Museum. From papers in the museum's collections.

CHAPTER FIVE
1. Garrett, Franklin. *Atlanta and Environs: A Chronicle of Its People and Events*. p. 143.
2. Ibid., p. 145.
3. Bining, A.C. *The Rise of American Economic Life*. pp. 322–323.

CHAPTER SIX
1. Housch, Linda Gail. The *Daily Times*. March 23, 1969. p. 9C.
2. Coleman, Kenneth. *A History of Georgia*. p. 151.
3. Ibid., p. 151.
4. Piston, William Garrett. *Lee's Tarnished Lieutenant*. p. 68.

5. Ibid., p. 137.
6. Ibid., p. 155.

CHAPTER EIGHT

1. Jackson, Olin. *A North Georgia Journal of History*. p. 83.
2. From *Georgia Life Magazine* as quoted in *A North Georgia Journal of History*, p. 84.
3. Noble, Ben, and Olin Jackson. *Lakemont, GA: The Early Years*. p. 1.
4. Ritchie, Andrew Jackson. *Sketches of Rabun County History*. p. 431.

CHAPTER TEN

1. Dorsey, James. *The History of Hall County, Georgia*. p. 261.
2. Ritchie, Andrew Jackson. *Sketches of Rabun County History*. p. 483.
3. Roberts, William P. *Georgia's Best Kept Secret: A History of North Georgia College*. p. 7.
4. Lane, Mary C. *History of Piedmont College*. p. 23.
5. Ibid., p. 35.

CHAPTER ELEVEN

1. Bining, Arthur Cecil. *The Rise of American Economic Life*. p. 359.
2. *Industrial Georgia*. A booklet located in the Textile Room at the Georgia Mountain History Museum at Brenau University.

CHAPTER THIRTEEN

1. Lumsden, Tom. *Nacoochee Valley: Its Times and Its Places*. p. 10.

CHAPTER FOURTEEN

1. Davis, Robert Scott, Jr. An article in *A North Georgia Journal of History*. Vol. II. p. 214.
2. Ibid., p. 214.
3. Ibid., p. 217.
4. Dabney, Joe. *Mountain Spirits*. p. XIV.

CHAPTER FIFTEEN

1. Sawyer, Gordon. *The Agribusiness Poultry Industry*. p. 92.
2. *Georgia Review*. Fall, 1952.
3. Sawyer, Gordon. *The Agribusiness Poultry Industry*. p. 155.
4. Ibid., p. 103.

CHAPTER SIXTEEN

1. Coughlin, Robert David. *Lake Sidney Lanier*. Preface.
2. Cook, Joe, and Monica Cook. *River Song*. p. 256.

CHAPTER SEVENTEEN

1. Muir, John. *A Thousand-mile Walk to the Gulf*. p. 44.

BIBLIOGRAPHY

BOOKS

Arnall, Ellis Gibbs. *The Shore Dimly Seen*. New York: Lippincott, 1946.

Bass, Robert D. *Ninety Six*. Sandlapper, 1978.

Bining, Arthur Cecil. *The Rise of American Economic Life*. New York: Charles Scribner's Sons, 1943.

Brice, W.M. *A City Laid Waste*. Self-published. 1936. Reprinted Gainesville, GA: Georgia Printing Co., 1986.

Burrison, John A. *Brothers in Clay: The Story of Georgia Folk Pottery*. Athens: University of Georgia Press, 1983.

Cain, Andrew. *History of Lumpkin County for the First Hundred Years*. Spartanburg, SC: the Reprint Co., 1978.

Calloway, Colin G. *The American Revolution in Indian Country*. New York: Cambridge University Press, 1995.

Cashin, E.J. *The Story of Augusta*. Spartanburg, SC: the Reprint Co., 1980.

Coleman, Kenneth. *A History of Georgia*. Athens and London: University of Georgia Press, 1991.

Cook, Joe, and Monica Cook. *River Song: A Journey down the Chattahoochee and Apalachicola Rivers*. Tuscaloosa: University of Alabama Press, 2000.

Coughlin, Robert David. *Lake Sidney Lanier: A Storybook Site*. Atlanta: RDC Productions, 1998.

Dabney, Joseph Earl. *Mountain Spirits*. Asheville, NC: Bright Mountain Books, 1974.

Dorsey, James E. *The History of Hall County, Georgia*. Vol. I. Gainesville, GA: Magnolia Press, 1991.

Eckenrode, H.J., and Bryan Conrad. *James Longstreet: Lee's War Horse*. Chapel Hill: University of North Carolina Press, 1936, 1986.

Ehle, John. *Trail of Tears: The Rise and Fall of the Cherokee Nation*. New York: Doubleday, 1988.

Freeman, Douglas Southall. *Lee's Lieutenants: A Study in Command*. New York: Charles Scribner's Sons, 1949.

Garrett, Franklin M. *Atlanta and Environs: A Chronicle of Its People and Events*. Athens: University of Georgia Press, 1954.

Gedney, Matt. *Living on the Unicoi Road*. Marietta, GA: Little Star Press, 1996.

Grady, Henry. *The New South: Writings and Speeches of Henry Grady*. Savannah: Beehive Press, 1971.

Harshaw, Lou. *The Gold of Dahlonega*. Asheville, NC: Hexagon Company, 1976.

Hemperley, Marion R. *Indian Heritage of Georgia*. Athens: the Garden Club of Georgia, 1994.

Jackson, Joseph Henry. *Anybody's Gold: The Story of California's Mining Towns*. San Francisco: Chronicle Books, 1970.

Jackson, Olin. *A North Georgia Journal of History*. Woodstock, GA: Legacy Communications, Inc., 1989.

———. *A North Georgia Journal of History*. Vol. II. Alpharetta, GA: Legacy Communications, Inc., 1991.

———. *A North Georgia Journal of History*. Vol. III. Roswell, GA: Legacy Communications, Inc., 1995.

———. *A North Georgia Journal of History*. Vol. IV. Roswell, GA: Legacy Communications, Inc., 1999.

Jones, S.P. *Second Report on the Gold Deposits of Georgia*. 1909. Reprint, Atlanta: DNR-Georgia Geological Survey, 1983.

Kephart, Horace. *Our Southern Highlanders*. Knoxville: University of Tennessee Press, 1913.

Lane, Mary C. *History of Piedmont College*. Demorest, GA: Piedmont College Press, 1993.

Lumsden, Thomas N. *Nacoochee Valley: Its Times and Places*. Sautee-Nacoochee, GA: self-published, 1989.

McCullar, Bernice. *This Is Your Georgia*. Montgomery, AL: Viewpoint Publications, 1968.

Massey, Katharine, and Laura Glenn Wood. *The Story of Georgia for Boys and Girls*. Boston: D.C. Heath & Co., Publishers, 1904.

Muir, John. *A Thousand-mile Walk to the Gulf*. New York: Houghton Mifflin Co., 1916. Reprinted by First Mariner Books, 1998.

Noble, Ben, and Olin Jackson. *Lakemont, GA: The Early Years*. Woodstock, GA: Legacy Communications, 1989.

Otwell, W. Larry. *The Gold of White County, Georgia*. Lakemont, GA: Copple House Books, 1984.

———. *Panning Georgia's Gold*. Lakemont, GA: Copple House Books, 1984.

Piston, W.G. *Lee's Tarnished Lieutenant*. Athens and London: University of Georgia Press, 1987.

Rensi, Ray C., and H. David Williams. *Gold Fever: America's First Gold Rush*. Atlanta: Georgia Humanities Council, 1988.

Ritchie, Andrew Jackson. *Sketches of Rabun County History*. Clayton, GA: Rabun County Historical Society, 1948.

Roberts, William Pittman. *Georgia's Best Kept Secret: A History of North Georgia College*. Dahlonega, GA: North Georgia College Alumni Association, 1998.

Robinson, W. Stitt. *The Southern Colonial Frontier 1607–1763*. Albuquerque: University of New Mexico Press, 1979.

Rouse, Parke, Jr. *The Great Wagon Road: From Philadelphia to the South*. Richmond, VA: the Dietz Press, 1995.

Sawyer, Gordon. *The Agribusiness Poultry Industry*. New York: Exposition Press, 1971.

Schlesinger, Arthur M., Jr. *The Age of Jackson*. Boston: Little, Brown & Co., 1950.

Scruggs, Carroll Proctor. *Georgia during the Revolution*. Norcross, GA: Bay Tree Grove, Publishers, 1976.

———. *Georgia Historical Markers*. Helen, GA: Bay Tree Grove, Publishers, 1973.

Shadburn, Don L. *Cherokee Planter in Georgia: 1832–1838*. Roswell, GA: W.H. Wolfe Associates, 1990.

Snow, William P. *Lee and His Generals*. New York: Random House/Gramercy Books, 1996.

Webb, J.A. *The History of New Holland, Georgia, and Pacolet Mfg. Co.* Gainesville, GA: self-published, 1985.

White, George. *Historical Collections of Georgia*. New York: Pudney & Russell, 1854. Reprinted Danielsville, GA: Heritage Papers, 1968.

White, Max. E. *Georgia's Indian Heritage*. Roswell, GA: W.H. Wolfe Associates, 1988.

NEWSPAPERS AND JOURNALS

Atlanta Business Chronicle
Atlanta Journal Constitution
Augusta Sentinel-Chronicle
The *Gainesville Eagle*
The *Gainesville News*
Georgia Life Magazine
The *Georgia Review*
National Geographic
Native Peoples
North American Review
North Georgia Journal
Poultry Times
The Times

INTERVIEWS AND MISCELLANEOUS

Alter, Norman Bruce. *Chattahoochee-Oconee National Forests*. Unpublished study. 1971.

Chicopee Mfg. Company booklet. Located in the Textile Room of the Georgia Mountain History Museum at Brenau University.

Gainesville. Promotional brochure, 1888.

Georgia Railway and Power Co. *Industrial Georgia*. Promotional booklet. 1923.

A Hall County History. Unpublished.

Lumsden, Tom. Interview. 1998.

Otey, Wilbur. Interview. 1997.

Piedmont Air Line Route. Promotional brochure, 1878.

Sherwood, Adiel. *Gazetteer of the State of Georgia*. Philadelphia, 1829.

Wynn, Jack. Interview. 1998.

INDEX